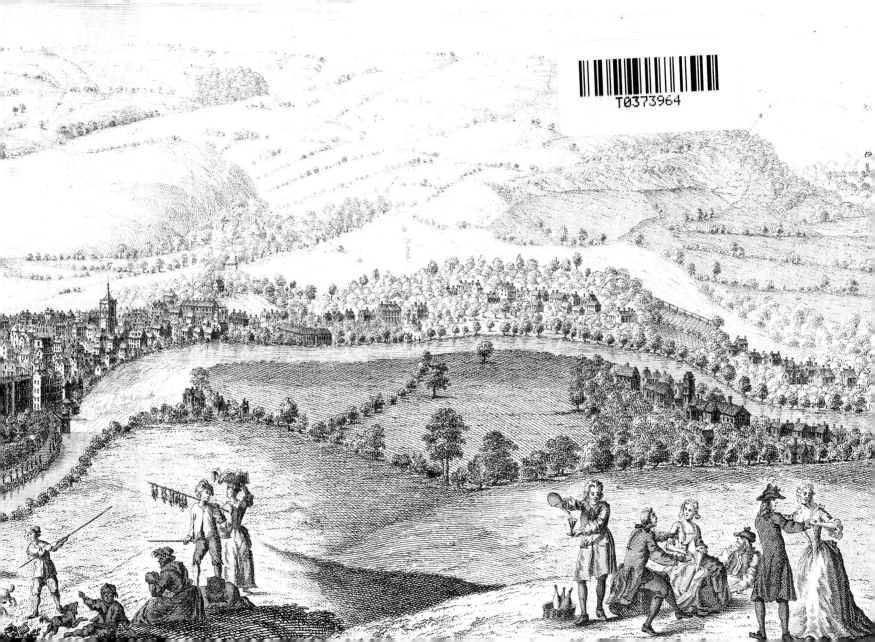

Acknowledgements and Copyright

We would like to acknowledge the following people for their significant contributions and encouragement in creating this book: Stephen Bird, David Lawrence and Judith Zedner from Bath & North East Somerset Council; Peter Rollins from Thermae Bath Spa; Malcolm Toogood and Trevor Quartermaine from The Old Orchard Street Theatre and Masonic Hall; Sharon Love from The Royal Crescent Hotel; Victoria Barwell from No.1 Royal Crescent; Simon Castens; Michelle West; Dr Lucy Rutherford from Bath Abbey; Bath's people and visitors for adding life to this wonderful city and above all the staff at Bath Central Library for providing the catalyst for Bath in Time by allowing access to their unique Special Collections.

A special thank you to Trevor Osborne of The Osborne Group for his help in bringing this project to publication.

Produced by The Everything Curious Company, Unit 130, 3 Edgar Buildings, George Street, Bath, BA1 2FJ, United Kingdom.

Historical images © 2011 Bath in Time and sourced from the Special Collections at Bath Central Library.

Contemporary photographs © 2011 Dan Brown, Andy Clist, Mark Gibson, Jess Loughborough, Richard Schofield and Christina West.

Contemporary photographs on pages 9, 10, 15 and 16 also © 2010 Bath & North East Somerset Council.

Text © 2011 Dr Cathryn Spence.

Published by The History Press.
Reprinted 2011, 2017, 2018, 2021 2025

Design by Christina West.
www.christinawest.co.uk

Front and back inside cover: Samuel and Nathaniel Buck, *The South East Prospect of the City of Bath,* **1734, copper engraving**

Select Bibliography

Davis, Graham and Bonsall, Penny, *A History of Bath – Image and Reality*, Carnegie Publishing, Lancaster, 2006
Forsyth, Michael, *Bath – Pevsner Architectural Guide*, Yale University Press, London, 2003
Green, Mowbray A, *The Eighteenth Century Architecture of Bath*, George Gregory, Bath, 1904
Ison, Walter, *The Georgian Buildings of Bath from 1700 to 1830*, Faber and Faber, London, 1948
Spence, Cathryn, *The Bath Magazine*, various 'Building Bath' features, Bath, 2004-10
Wood, John, *A Description of Bath*, 2nd edition, Bathoe & Lownds, London, 1765
Wroughton, John, *Tudor Bath: Life and Strife in the Little City, 1485-1603*, Lansdown Press, Bath 2006

Publisher's Note:
The inclusion of a photograph in this book does not necessarily imply unrestricted public access to the location illustrated.

Printed and bound by Imak, Turkey.

The paper is made entirely from virgin pulp derived from forests managed under the Forest Stewardship Council's rules.
The printer holds the FSC chain of custody SGS-COC-005091. By undertaking all printing and binding on one site, further environmental savings in terms of transport and energy are achieved.

ISBN 978-07524-5674-4

Bath

City on Show

Contemporary photography by
Dan Brown
Andy Clist
Mark Gibson
Jess Loughborough
Richard Schofield
Christina West

Text by Dr Cathryn Spence

Historical images from *Bath in Time* from the collection at Bath Central Library
www.bathintime.co.uk

Published by The History Press, 97 St George's Place, Cheltenham, Gloucestershire, GL50 3QB
www.thehistorypress.co.uk

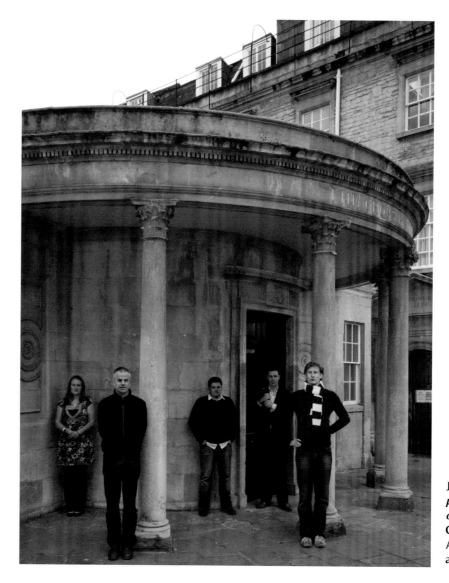

Jess Loughborough, *The photographers for this book outside the Cross Bath,* 2009. Christina West, Dan Brown, Andy Clist, Richard Schofield and Mark Gibson.

Foreword Dan Brown

For those of us lucky enough to live and work in Bath, the magic of the city can be taken for granted, with the demands and distractions of modern living masking the beauty of our surroundings.

2007 marked the launch of *Bath in Time*, a web site dedicated to making accessible collections of historical images of Bath and its environs, as well as helping increase awareness, understanding and appreciation of this special place.

Recognised by UNESCO in its entirety as a World Heritage Site, Bath has been a city of resort for centuries. Throughout that time artists, engravers and photographers have tirelessly sought to record the life, setting and architecture that has made Bath what it is today. Notable collectors of their day amassed vast private collections of these extensive works, and as these pass to the city, so *Bath in Time*'s digitisation project brings them to the attention and enjoyment of the wider public.

In *Bath – City on Show, Bath in Time* has joined forces with some of Bath's most talented photographers to produce a book showcasing the highlights of our surroundings, from outside and within. The carefully researched authoritative text helps guide the reader through Bath's glorious buildings, magnificent setting, lively street life and unique hot springs.

Photographed from January to December and from dawn to dusk, the book's unique mix of old and new highlights how times and styles have changed, even if the timeless subjects remain constant throughout.

We hope you enjoy this book and are inspired by the surroundings in which it is set.

Copies of all these historical images, as well as many thousands of others, are available online at **www.bathintime.co.uk**.

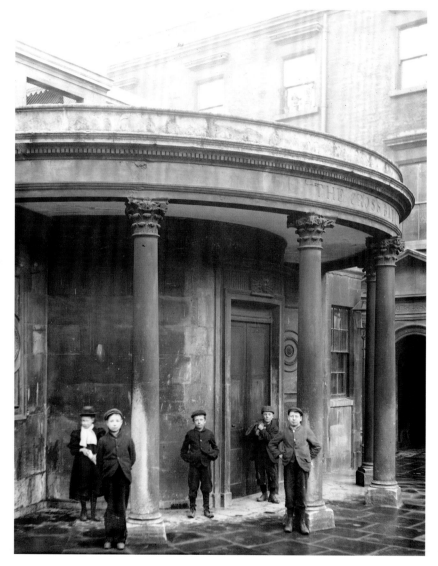

Mowbray A. Green (1865-1945),
*Street Urchins Outside the Cross
Bath,* c.1903, photograph

Introduction Dr Cathryn Spence

The iconic city of Bath enjoys an international reputation, but it is an unlikely success. Its position within a wide meander of the River Avon, surrounded by seven hills, in a hot and swampy valley, is not a natural place to make a settlement. Archaeological evidence has shown that during Neolithic times Bath was not permanently occupied. However, it is not unreasonable to imagine the spiritual draw Bath's natural thermal springs must have had for early man. It is these waters that truly define Bath's history.

The legend of Bath's discovery by the leprous Prince Bladud and his pigs (p.16) still resonates today, but our first real awareness of Bath being a strategic site dates from the Roman development of Aquae Sulis (before AD 75). Bath was a frontier town, located on the famous military boundary of the Fosse-Way. It is likely that there was a Roman fort here, but its exact location remains elusive. Nevertheless, Bath was an important resort and destination for pilgrims. The Romans made use of the waters early on, but it was not until the reigns of Nero and later Vespasian that the spa was properly developed with the building of a reservoir to contain the waters. *Sanitas per aqua*, or spa for short, literally means health through water. The small walled city of 24 acres flourished and Bath became a major religious spa centre.

Sometime in the 5th century the baths and public buildings ceased to be maintained and Bath's popularity dwindled. Like much of Britain, Bath's post-Roman or Dark Age history is unclear. However, by the Middle Ages Bath enjoyed a revival thanks to the dominance of the Abbey and the wool and cloth trade. A successful market town, Bath enjoyed a buoyant economy, although its reputation was of being provincial and unsophisticated. The healing waters drew the sick and infirm desperate for 'the cure'. In 1668, Samuel Pepys wrote in his diary, 'Methinks it cannot be clean to go so many bodies together in the same water'. The Corporation, or town council, failed to maximise the benefits of the waters for themselves, instead preferring to lease the running of the baths to independent businessmen.

Bath was consistently popular with the monarchy, but the royal credited with changing Bath's fortunes and paving the way for its Georgian boom is Queen Anne. Anne visited whilst still a princess in 1692, and again in 1702 and 1703, and fashionable society followed. Bath's potential was capitalised on by the Master of Ceremonies, Richard 'Beau' Nash (1674-1762), who organised the entertainment and promoted Bath as the place to be seen. The seasonal visitors were known as the Company and in the early 18th century comprised the wealthy elite. All who mattered came to Bath.

It was only towards the end of the 17th century that Bath started to emerge beyond the restrictive medieval wall system. The modern and ambitious plans of architect-surveyor John Wood (1704-54), in partnership with entrepreneur and quarry owner Ralph Allen (1693-1764), saw the city spread out, resulting in the truly magnificent city we still admire today.

Driven by profit, the 'valley of pleasure' was built speculatively, with hundreds of people cashing in on Bath's boom. Unfortunately, its very success was its undoing. The elite had been attracted by the city's quaint exclusiveness, but now anyone could go to Bath. Rejected by the truly chic for the alternative seaside resorts, Bath's reputation of being uncouth returned. This was the Bath Jane Austen knew – an overcrowded 'cattle-market' of spouse hunters. Sadly, it became more fashionable to dislike Bath. The city was mortgaged to the hilts by the late 18th century, and when the banks crashed in 1793 so did Bath.

Despite maintaining its industrial and commercial edge, the next century saw Bath epitomised as a place for genteel retirement. In actual fact, Bath doubled in size with the building of working class homes in the suburbs of Oldfield Park, Weston, Twerton and Larkhall, whilst Bath engineering firm Stothert & Pitt dominated the production of cranes for 200 years. Bath's heritage was targeted by enemy bombing during World War II, and as a consequence large areas were cleared and replaced with unpopular 1960s high-rises. Since the 1980s, Bath has enjoyed a revival and is now recognised as a world-class city of festivals and cultural tourism.

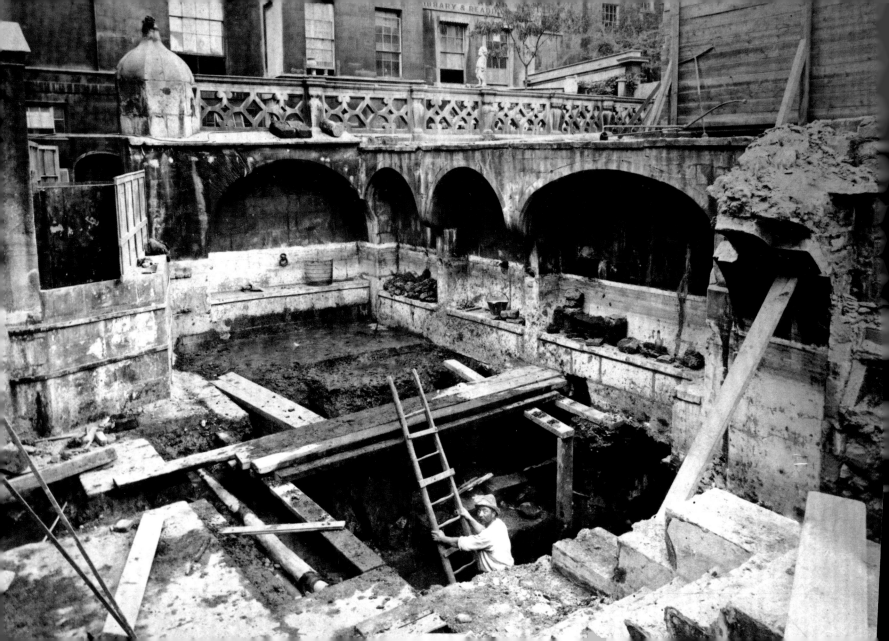

(facing) *Emerging from below the Queen's Bath*, **1885, photograph**

The significance of this early photograph cannot be overestimated. A worker emerges from the Roman Circular Bath discovered during the demolition of the Queen's Bath, built in 1576. Over the centuries, flooding from the River Avon and elsewhere saw the Roman Great Bath complex lost under a sea of black mud. An attempt to solve a leak from the King's Bath, in 1878, led to one of the most momentous archaeological finds this country has witnessed – the discovery of the Roman Sacred Spring, reservoir and Great Bath.

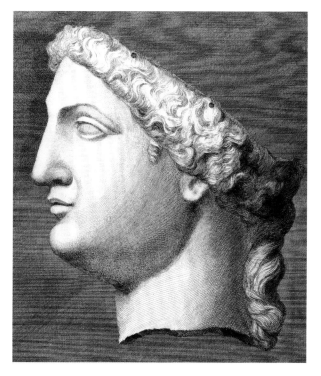

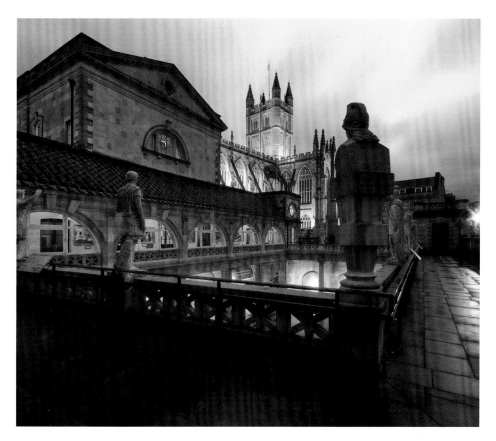

(above) George Vertue (1684-1756) (after A. Gordon), *The Head of Minerva*, **engraving**

The gilded bronze head of the goddess Minerva was discovered during the digging of a sewer beneath Stall Street in 1727. This magnificent object, which would have originally stood in the Temple, is now on display at the Roman Baths Museum. The Romans recognised that Minerva's qualities of healing and wisdom were similar to those bestowed on the native deity Sulis. Inscriptions found on offerings cast into the Sacred Spring show that the two were considered one and the same, creating the unique goddess Sulis Minerva.

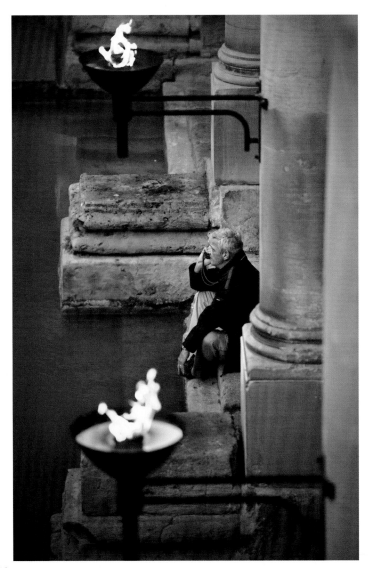

Despite being City Surveyor and the tenacious exponent for the excavation and sympathetic preservation of what has become Bath's most popular heritage attraction, Major Charles Edward Davis (1827-1902) did not win the contract to design the Roman Baths Museum and Concert Room extension to the Grand Pump Room. Instead, the job was awarded to John McKean Brydon (1840-1901) a Scottish architect working in London.

(below) *Roman Baths, North East View of Great Roman Bath,* **c.1880, photograph**
Davis planned to cover the Great Roman Bath with a vaulted roof, which would have been more authentic. Brydon's superstructure features an open Tuscan colonnade and pierced balustrade (facing), reminiscent of the medieval balustrade that encloses the King's Bath. The Great Bath is watched over by statues of Roman dignitaries (p.9 and p.15) by fellow Scot, George Anderson Lawson (1832-1904).

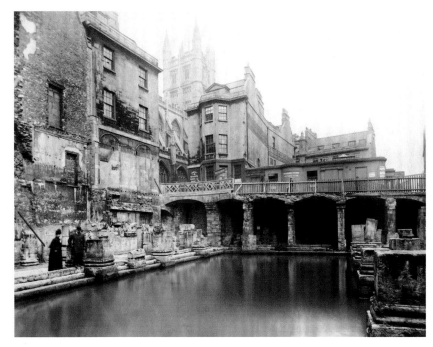

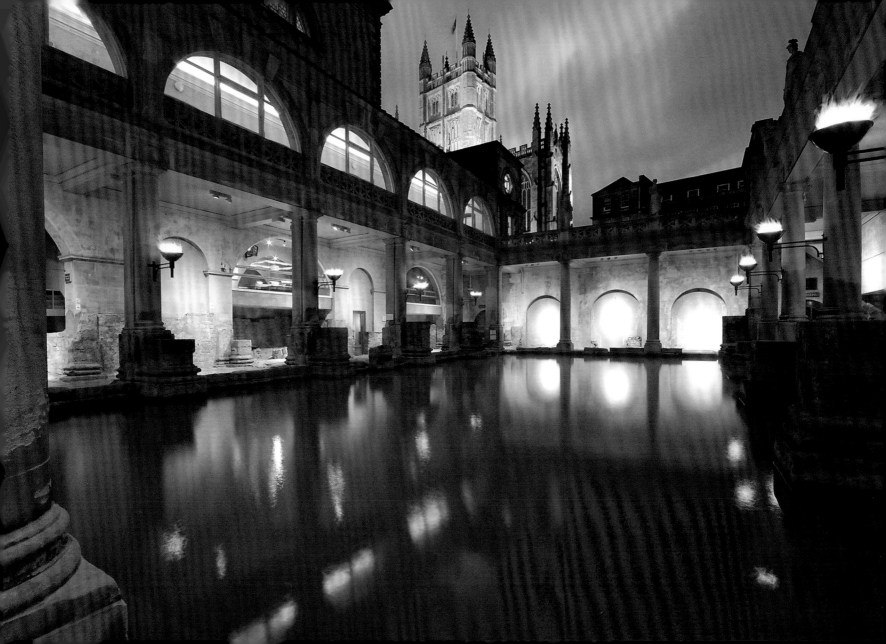

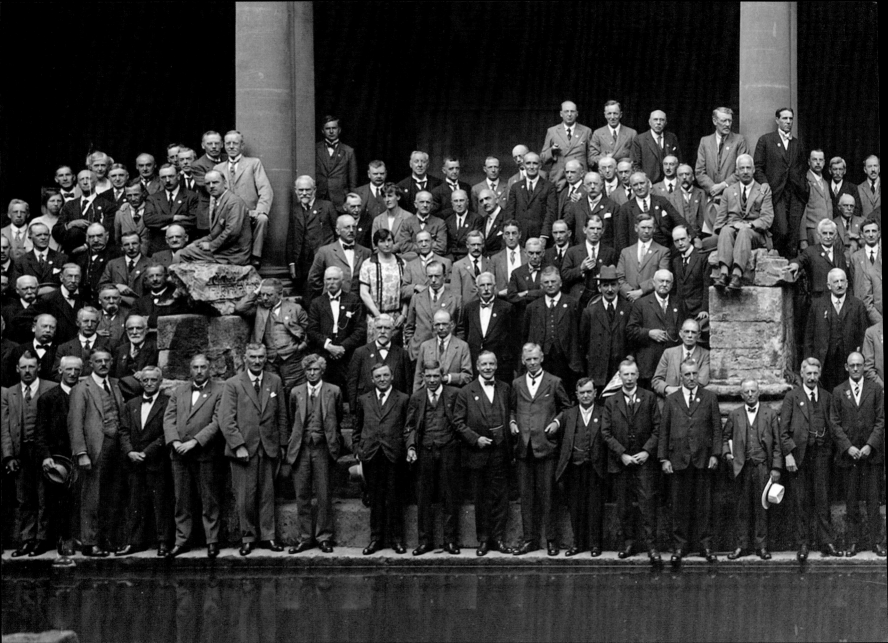

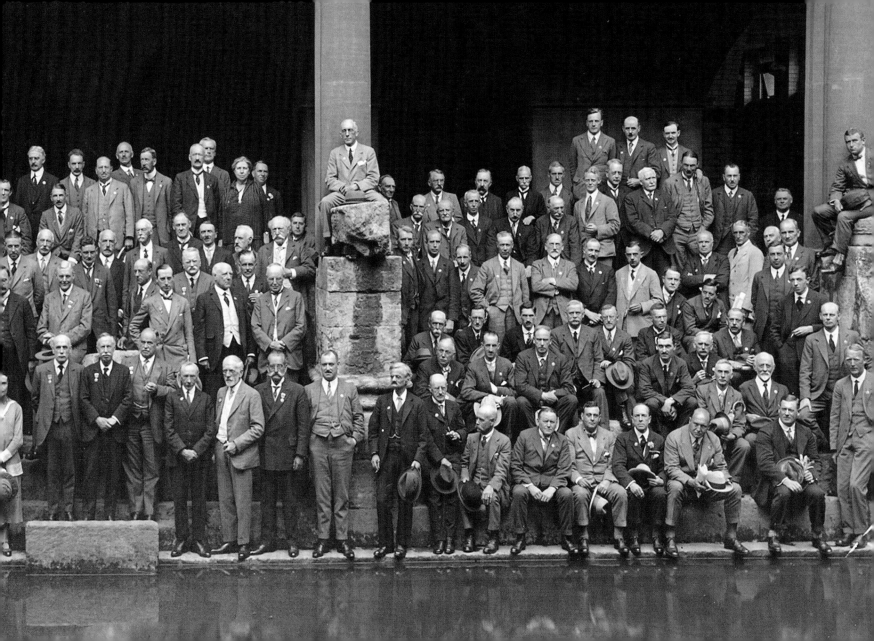

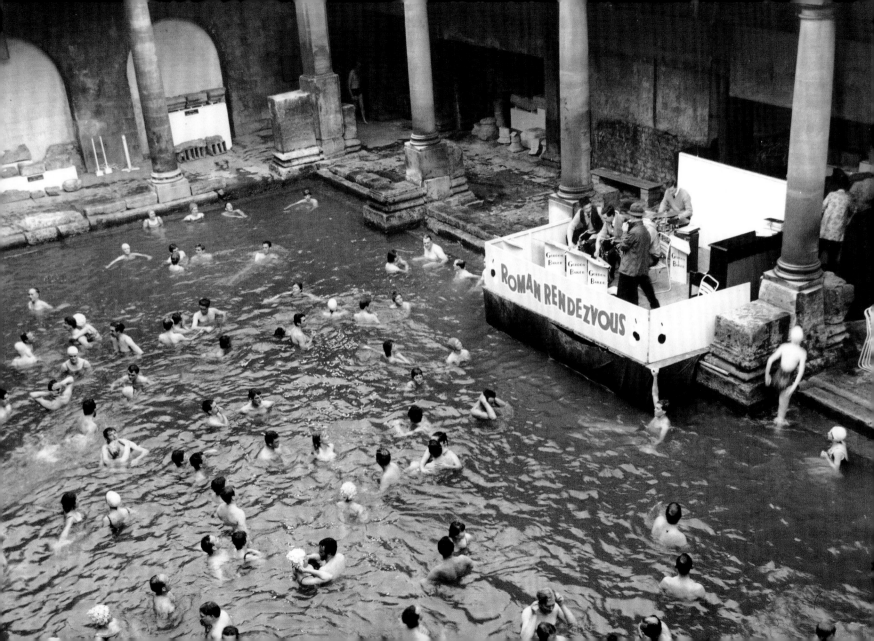

(previous) *British Medical Association, Annual Meeting, 17-25 July 1925,* **photograph at the Great Bath**
(facing) *The Roman Rendezvous, Great Bath, c.1965,* **photograph**

Between 1962 and 1978, a Roman Rendezvous launched the Bath Festival. This annual event allowed ticket holders the privilege of swimming in the Great Bath, followed by dancing in the Grand Pump Room. In spite of being criticised for having little to do with a music festival, the Roman Rendezvous quickly became legendary.

(right) *Discoveries from the Excavations of the Roman Baths, c.1888,* **photograph**

The discovery of the Roman Baths reignited interest in the spa, and the Corporation seized the opportunity to provide the Victorian visitor with better facilities. In just ten years the number of bathers rose by 68%.

The Roman Baths Museum is designated 'an outstanding collection' of national and international significance by the British Government. The attraction is one of the best-preserved Roman sites in the world, and welcomes over a million visitors every year.

Legend has it that in the 9th century BC, Prince Bladud, son of King Ludhudibras, founded Bath as a symbol of his gratitude for the curative powers of the springs. Having contracted leprosy, Bladud was cast out and forced to roam the country as a swineherd. He noticed that the skin on his pigs became free of sores and blemishes after they had wallowed in the hot, steamy and swampy valley. Immersing himself in the thermal waters, Bladud was cured and joyfully accepted back into his father's court.

In time Bladud was crowned King. A statue of Bladud (right) has guarded the King's Bath (below) since at least the 16th century. The bath itself may have been built in the early 12th century by Bishop John de Villula, who made Bath his cathedral seat. Contained within the monastery grounds, the King's Bath was named after Henry I. Bathers descended the steps (or 'slips') and through the arches to the bath. Further arches housed stone seats and areas for bathers to stand.

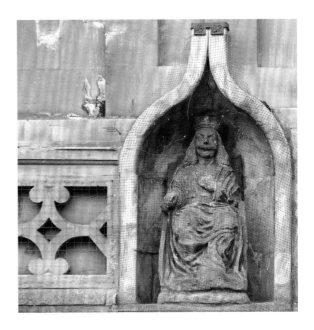

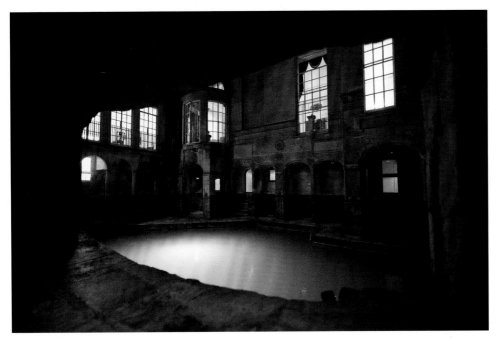

(facing) John Nixon (c.1750-1818), *The Pump Bath at Bath or The King's Bath,* 1801, engraving
Whilst the rest of Bath was 'a rage of building', the Georgians made few modifications to the baths, although the King's Bath was dramatically reduced in size when the Pump Room was extended in 1751 and again in 1790-5.

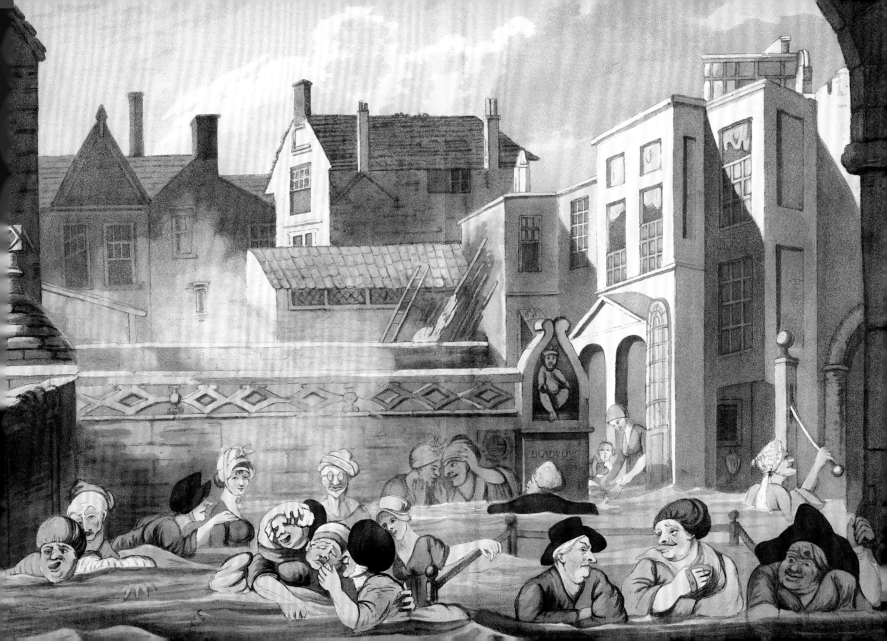

(below) *Kingston Parade and Kingston Baths*, **c.1920, photograph**

The open space of Kingston Parade makes it an ideal place to people-watch, listen to buskers and enjoy various special events such as the World Heritage Day celebrations (facing) and the setting for the world record for mass participation waltzing (right). Originally part of the Priory, the area was acquired by the Duke of Kingston. In 1755, he demolished Abbey House to make way for Abbey Street and Church Street.

During these works, remains of the Roman baths were discovered. However, rather than continue to excavate, the Duke built a suite of private baths and a small pump room. These facilities were further improved and enlarged by Dr Wilkinson between 1809 and 1850 and then acquired by the Corporation in 1870. The Kingston Baths were demolished in 1923 for the excavation of the Roman East Baths and the area paved over to create the present courtyard.

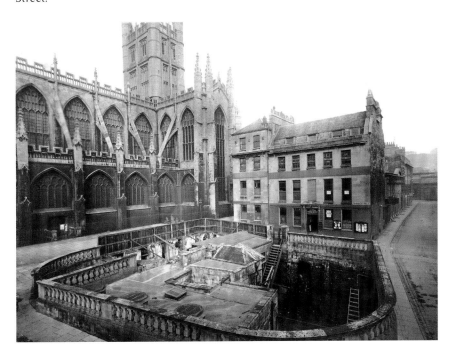

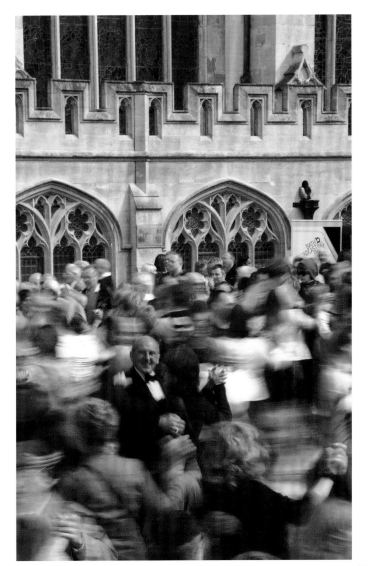

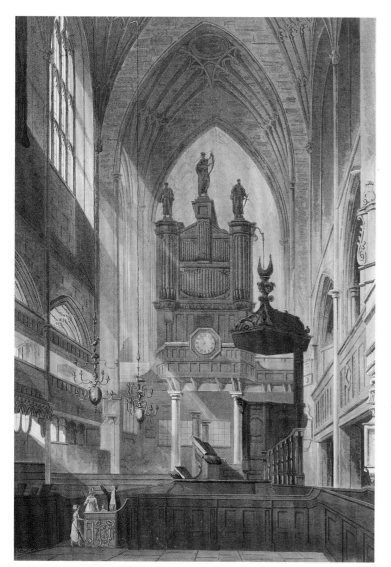

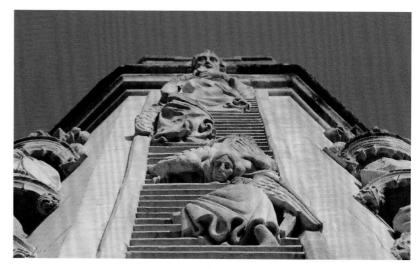

(left) John Claude Nattes (1765-1822), *Interior of the Abbey,* **1805, aquatint**

Bath Abbey lies physically – and historically – at the centre of the city. At least three churches have stood on this site, the first an Anglo-Saxon Abbey dating from 757. This was replaced by the Norman cathedral, begun by John of Tours in 1090. It is Tours who ultimately created the dual Somerset Diocese of Bath and Wells. At 300ft (91.4m) long, Tours's creation was a far larger structure than we have now – the current Abbey is comparable to the size of merely the Norman nave.

The present Abbey was begun in 1499, instigated by Bishop Oliver King (c.1432-1503) who had a dream in which he heard God's message 'Let an Olive establish the Crown, and let a King restore the Church'. King's vision is commemorated in the ascending and descending angels on the carved ladders of the west front (above). After Henry VIII's dissolution of the monasteries in 1539, the Priory was sold to Humphrey Colles who rapidly sold it on to Matthew Colhurst. Having gained Elizabeth I's approval, Colhurst's descendent Edmund gave the 'very ruinous' Abbey back to the people of Bath in 1572. The Abbey was completed by 1617.

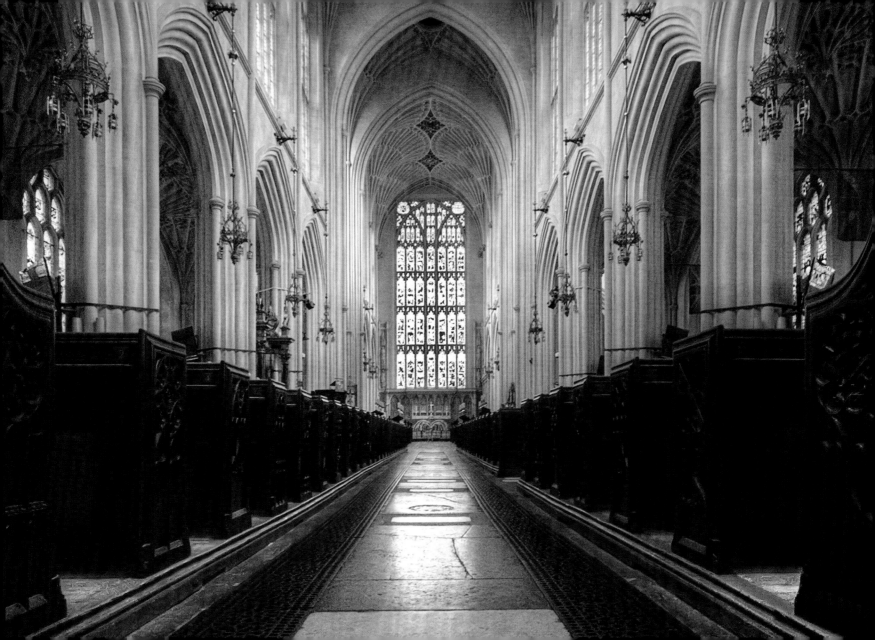

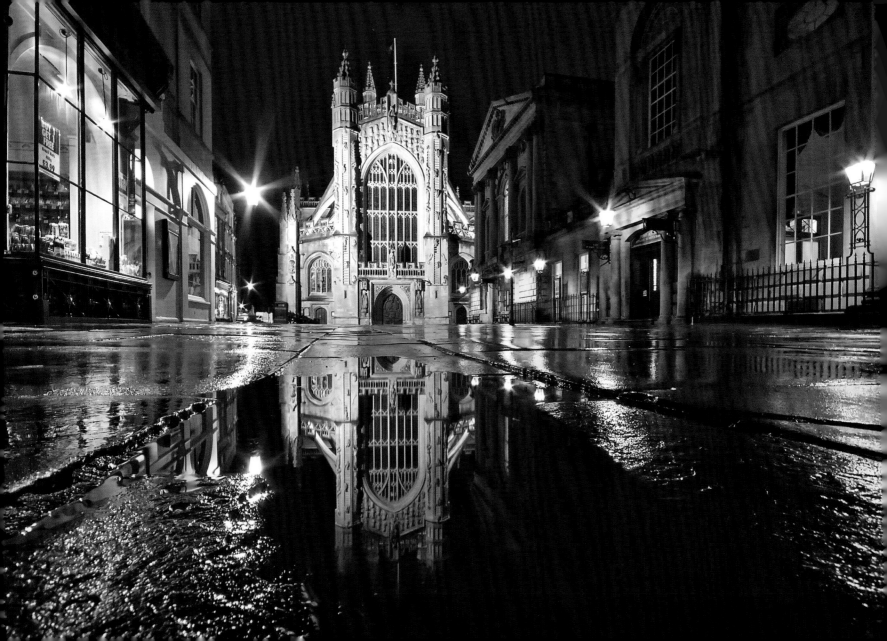

(right) John Carter (1748-1817), *Interior of the Abbey (detail).* Engraved by James Basire (1730-1802), published 1798

The Church of St. Peter's and St. Paul's actually ceased to be an abbey in 1087, and its cathedral status faltered in the 13th century. Nevertheless, the site has served as an important focus for Christian worship since Abbess Bertana founded a convent here in 676. The walls and floor are adorned with memorial tablets (below) that tell of the many worthies who have lived – and died – in Bath. Amongst the more notable are: Richard 'Beau' Nash; Admiral Arthur Philip; shorthand pioneer Isaac Pitman; artist William Hoare; US Senator William Bingham; and Lady Waller, wife of Roundhead leader William Waller. The external Gothic pinnacles and the fan vaulting in the nave both date from 19th century restorations: the first by George Phillips Manners (1789-1866) in 1833, and the second by Sir George Gilbert Scott (1811-78) in 1863-74. Robert and William Vertue undertook the fan vaulting in the choir during the early 1500s, and it is likely that Bishop Oliver's original intention was to continue this treatment into the nave.

(facing) *Interior of the Grand Pump Room,* **c.1912, photograph**

In 1705, John Harvey built Bath's first purpose-built pump room next to the King's Bath. An immediate success it was remodelled between 1732-4 and extended in 1751. In the 1790s the building was replaced by the Grand Pump Room, begun by Thomas Baldwin (c.1750-1820) and completed by John Palmer (1738-1817). The Pump Room was a popular place for fashionable society to meet during the day, listen to music and consult the Subscription Book, which detailed who was in town and where they were staying.

Lunch or high tea at the Grand Pump Room is a must for any visitor, but for those who are not tempted, the Abbey Church Yard is a bustling area of street theatre (below) and live music; it also serves as the meeting point for Bath's free walking tours conducted by the Mayor's Guides.

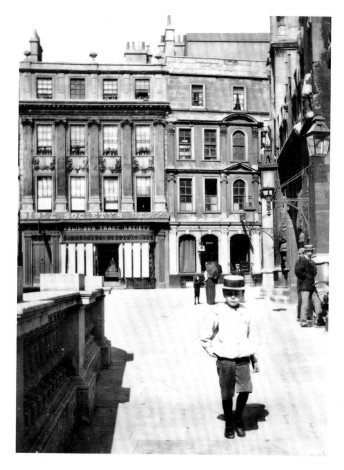

(above) *Towards Abbey Church Yard,* **c.1900, photograph**

In the background of this early photograph is Marshall Wade's House (c.1720). Wade (1673-1748) was one of the Duke of Marlborough's generals and came to Bath to crush a Jacobite plot, possibly on a tip-off from Ralph Allen. Although no documentary evidence has been found to link Wade with this important early Palladian house, it has always been assumed that he stayed here.

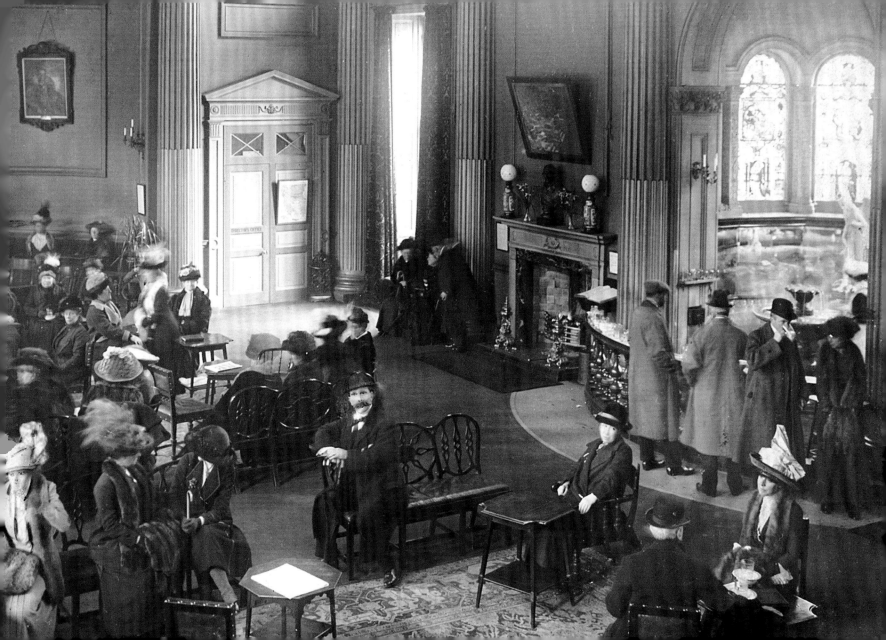

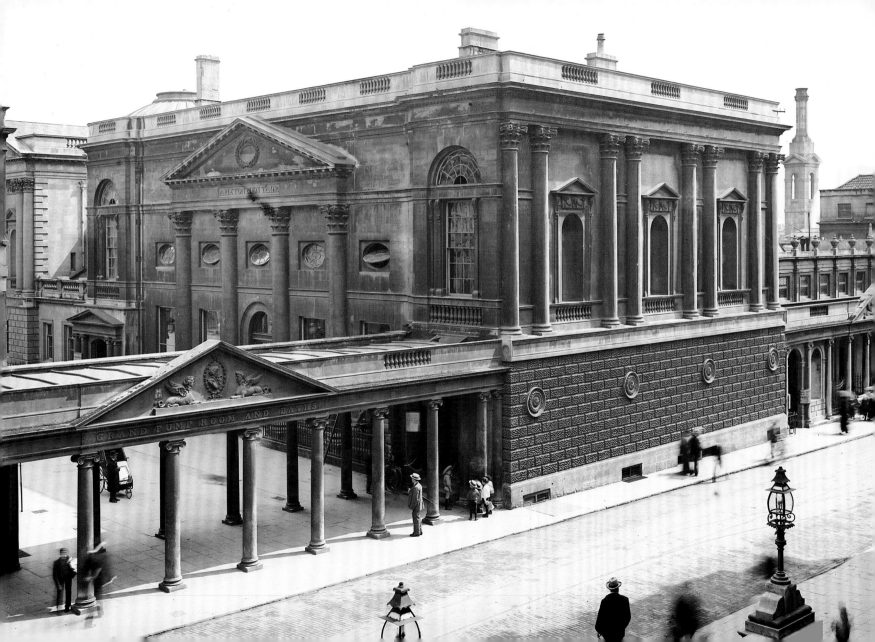

(facing) Mowbray A. Green, *Grand Pump Room and Colonnade, Stall Street*, c.1903, photograph

The baths, pump rooms and nearby assembly rooms were at the heart of Bath's phenomenal popularity during the 18th century. As Bath began to lose its appeal, so the Corporation invested in major improvements to attract visitors and cater for the new interest in swimming. The medieval legacy of cramped alleyways and irregular streetscape gave way to a more open and modern design as part of the Bath Improvement Act (1789). Thomas Baldwin's new design for the Grand Pump Room included this colonnade, divided into nine equal bays by ten Ionic columns. The triangular pediment features two sphinxes on either side of a wreath, surrounding the relief head of Hygeia with a serpent, a feature mirrored over the entrance to the baths. The inscription over the entrance to the new pump room is Greek for 'water is best'.

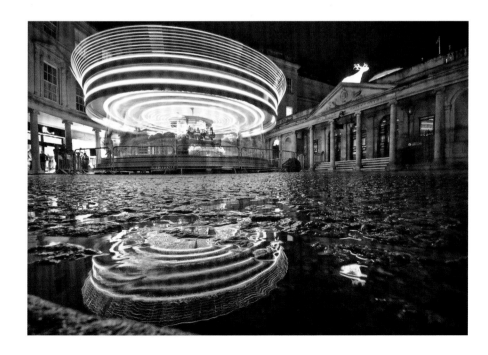

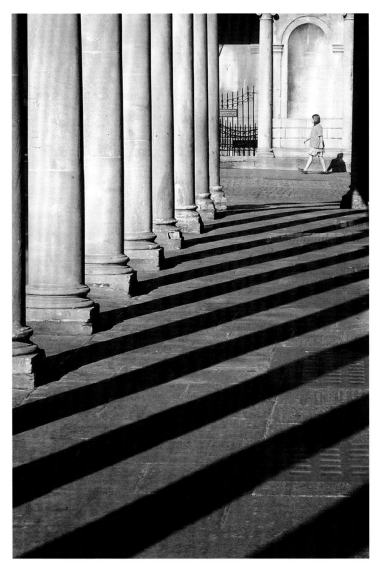

(facing) Mowbray A. Green, *Bath Street,* c.1903, photograph

Bath Street, with its Ionic colonnades and crescent-shaped termini, was laid out 'for the honour and dignity' of Bath in 1791 by Thomas Baldwin. It was to serve as a link between the Cross Bath, the New Private Baths in Stall Street, and the Grand Pump Room. In 1909, this unsuspecting street became the impetus for the founding of The Old Bath Preservation Society. Under the leadership of Prebendary S. A. Boyd, Rector of Bath Abbey, a small group of preservation pioneers successfully fought a scheme to demolish one side of Bath Street, in order to improve the facilities at the Victorian Grand Pump Room Hotel, which fronted Stall Street and abutted Bath Street.

Bath is rightly proud of its World Heritage Site status (below) awarded in 1987. UNESCO recognised the universal significance of Bath's Roman and Georgian heritage; including its important archaeological remains, town planning, Palladian architecture, landscape setting and natural hot springs. At a rate of 1.25 million litres (275,000 gallons) a day, Bath's hot mineral waters erupt at three springs within the city centre. Rainwater, which fell approximately 10,000 years ago, is heated by the earth's mantle to an estimated 69°C (156°F), cooling to an average 45°C (113°F) as it reaches the surface through faults in the limestone below Bath.

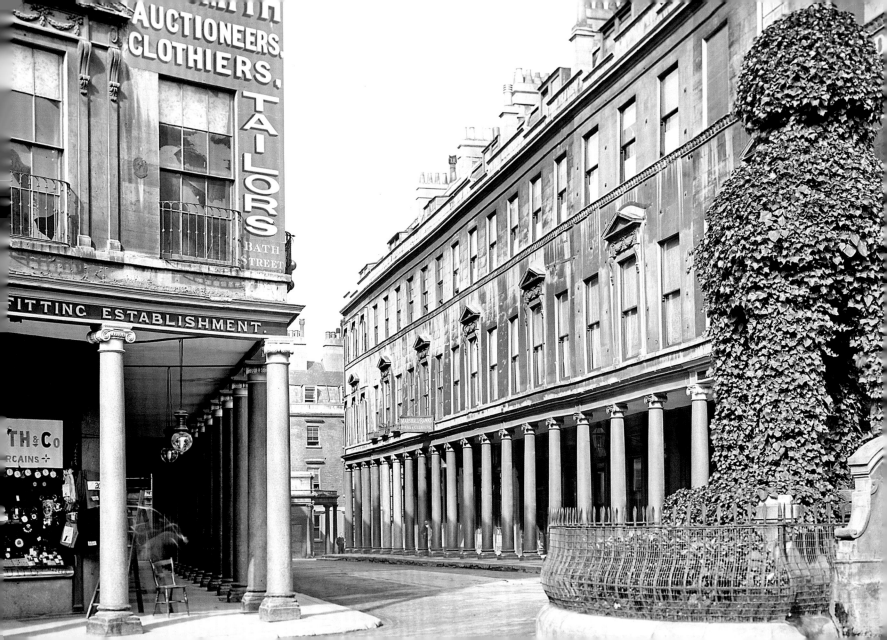

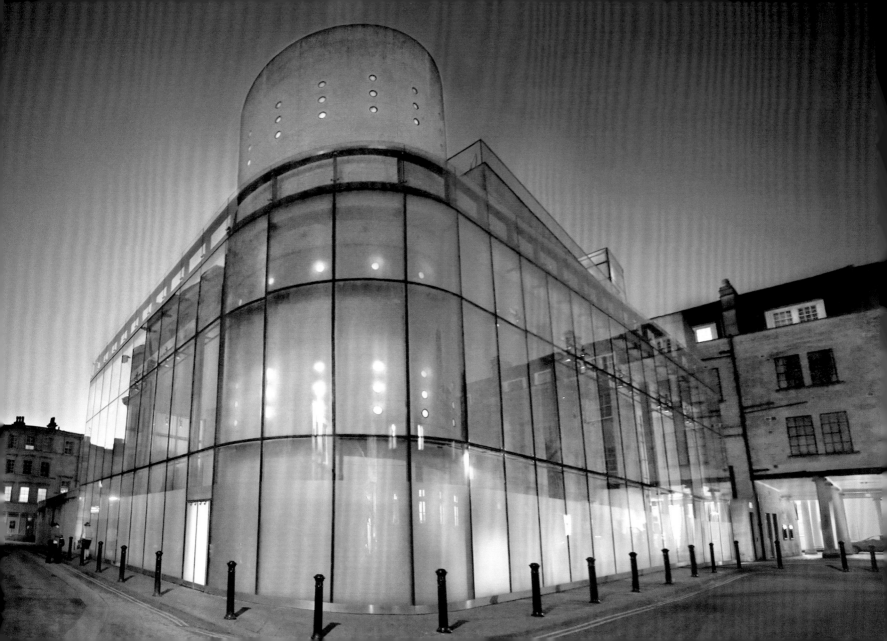

For over 10,000 years the natural thermal waters that rise in Bath have been a source of fascination, spirituality, pilgrimage and cure. Although the popularity of Bath's spa wavered over the millennia, the water has flowed constantly. In 1978, after contamination was discovered in the outdated pipework, Bath became a spa in name only. For almost 30 years litres upon litres of hot mineral water washed straight into the River Avon.

Throughout this period there were regular attempts to restore the spa, but all were defeated by the huge cost. In 1997, however, the Millennium Commission announced that it would support the Bath Spa Project with a grant worth £7.8 million. Working with Donald Insall Associates, architects Nicholas Grimshaw and Partners created an iconic new suite of baths and spa facilities, including the restoration of five historic buildings. The interplay of old and new is played out on the modern glass envelope surrounding the New Royal Bath, which dances with the reflections of the surrounding buildings (facing).

Over the centuries it has been claimed that Bath's waters could cure over 90 different ailments, including gout, dropsy, joint pain, leprosy and, significantly, infertility. James II's wife, Mary of Modena, happily conceived a male heir after a visit to the Cross Bath (p.38) in 1687, resulting in great publicity for Bath. Originally the Cross and Hot baths were frequented by the poorer classes, but by the late 16th century they were increasingly popular with higher society. This led to the establishment of the Lazours or Lepers Bath, fed from the overflow of the adjacent Hot Bath.

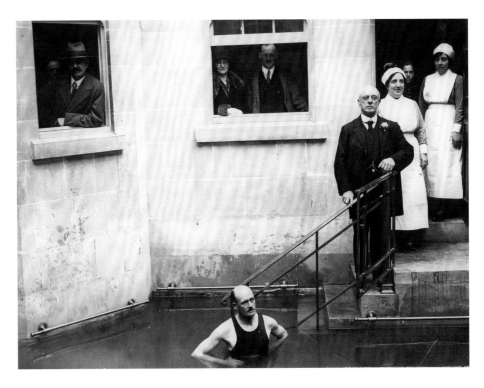

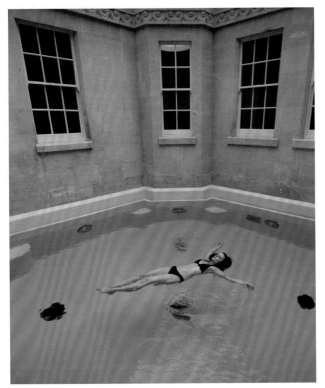

(above) *Opening of the Reconstructed Old Royal Baths (Hot Bath),* **22 October 1927, photograph**
This photograph marks the re-opening of the Hot Bath after a redesign by A. J. Taylor in 1925-7. From 1948 until 1976, treatment using Bath's mineral waters was available for all on the National Health Service. The Hot Bath (left) is fed by the hottest of the three springs – the Hot or Hetling Spring. Originally sited in the middle of Hot Bath Street, it was rebuilt (1775-7) in its new position by the Corporation, to a design by John Wood the Younger (1727-81). Grimshaw and Insall sympathetically restored Wood's symmetrical, square-within-a-square design, added a glazed roof and incorporated the building into the new Thermae Bath Spa as a treatment centre.

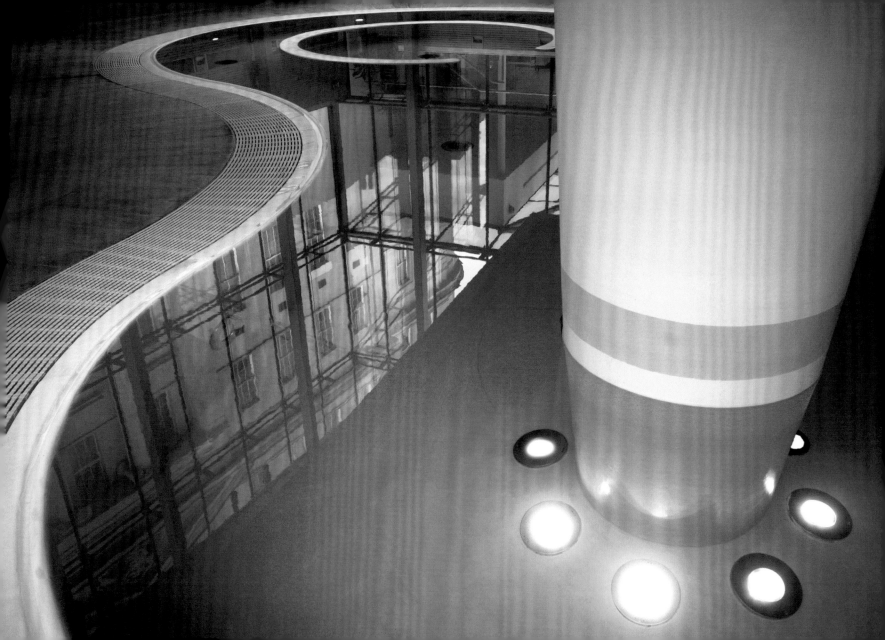

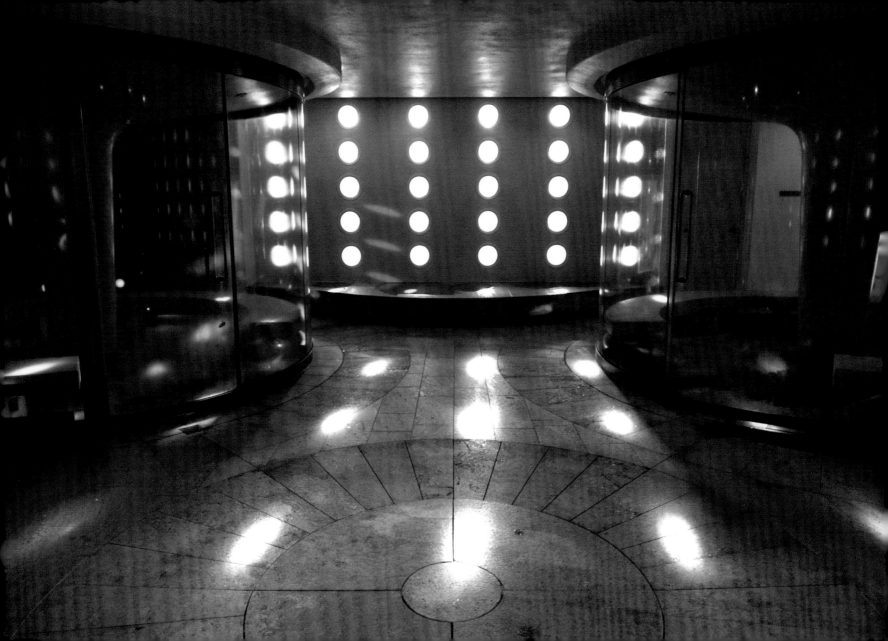

Grimshaw's contemporary design comprises a stone cube, resting on four great mushroom pillars, enveloped by glass. Within the strict rigidity of the building, the internal design plays on curves and circles and free-flowing sinuous lines. These forms are enhanced by the use of fibre optics to produce atmospheric lighting. On the ground floor is the Minerva Bath (p.33), above this the four circular steam room pods (facing), with portholes pierced through the stone cube to the outside.

Within the Hot Bath there are twelve treatment rooms which, along with the Inner Space and Massage Suite, offer over 50 different spa treatments. Separate, at the end of Bath Street, is the Cross Bath. Neglected, in the 19th century it became known as the Tuppenny Hot – a cheap swimming pool for locals. Now fully restored using the recently discovered original 18th century plans by John Palmer, locals can still enjoy special access rights.

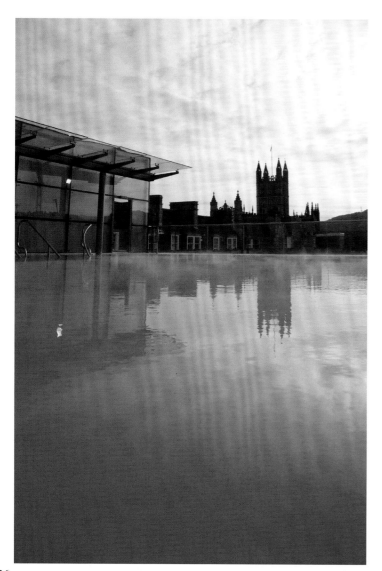

The crowning glory of the New Royal Bath is the open-air rooftop pool (left and facing). Basking in the hot mineral water, bathers can enjoy a unique view across Bath's skyline – an experience especially enchanting after dark. The site of the new spa was originally the Tepid Bath, built in 1829 by George Phillips Manners specifically for swimming. The water came from the King's Spring and was cooled in a large reservoir in York Street before being pumped into the bath.

(below) *The Beau Street Baths,* **c.1990, photograph**
In 1920, the Tepid Bath was demolished to make way for A. J. Taylor's Beau Street Swimming Bath. The baths successfully satisfied a demand, until the new leisure complex was built on the Recreation Ground in 1972. Beau Street, like the other baths in the city, was closed in 1978. In 1998, when the baths were demolished to make way for the new spa, a previously unrecorded Roman road was discovered. This was particularly unsettling as, over the years, swimmers had reported seeing the ghosts of Roman soldiers marching towards them.

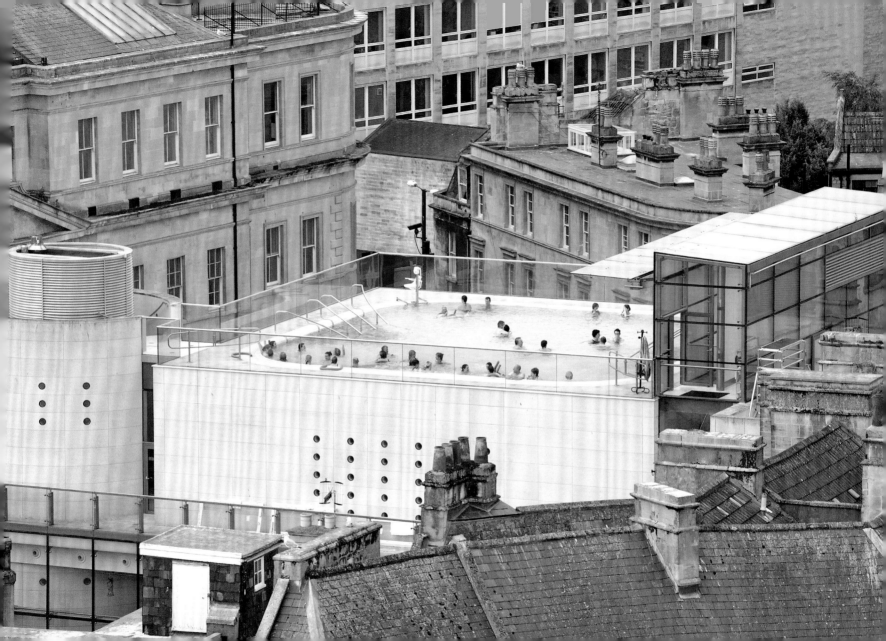

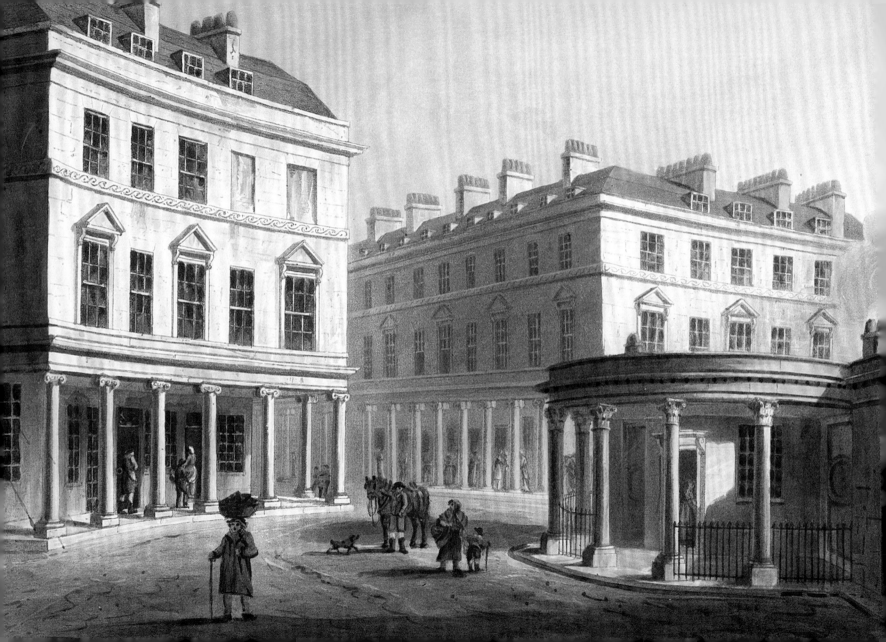

Like the King's Bath, the Hot Bath and Cross Bath date back to the early 1100s, with the sites having first been utilised by the Romans. The Cross Spring is now recognised as a sacred site. The bath probably took its name from being a place of pilgrimage, and as a consequence a cross was added during the Middle Ages. This was greatly enhanced by the Earl of Melfort after the birth of James II's son. Slowly dismantled, a surviving remnant from this cross is the cherub statue in a niche in Old Bond Street.

(facing) John Claude Nattes, *View of the Cross Bath,* **1804, aquatint**
The Cross Bath has had many forms over the centuries, but the structure we see now is principally by Thomas Baldwin, who rebuilt the bath and added a pump room in 1783, and John Palmer. After Baldwin's new Bath Street of 1791, the Cross Bath – which originally faced north – needed to be modified to complement the new layout. Palmer successfully undertook this alteration in 1797-8. The relief of Bladud (below) is after a painting by local artist and Royal Academian, William Hoare.

The palace façade of Queen Square (below, 1728-36) is heralded as one of the finest Palladian frontages of the time. Designed by John Wood this impressive residential square, with its wide streets, central park (facing) and modern neo-classical architecture must have shocked Bathonians who were more used to dark medieval alleyways and unsophisticated architecture. With the addition of St. Mary's Chapel (now demolished) on the west side of the square in 1732, Wood created the perfect 'town' within the city.

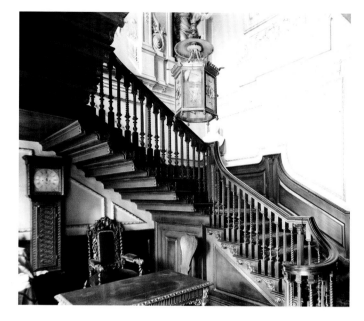

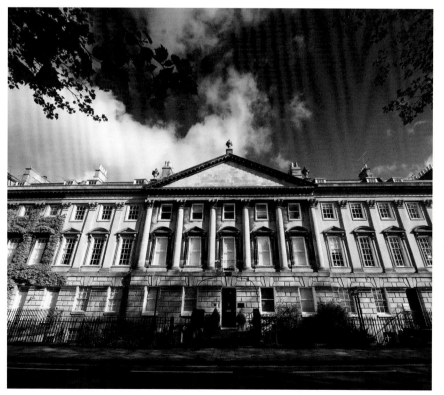

(above) **Mowbray A. Green, Staircase, 15 Queen Square, c.1903, photograph**
As long as the façade conformed to Wood's design, the interior was up to the individual – making them all unique. The finest ashlar stone was saved for the fronts, whilst the backs were constructed of a variety of materials and rubble stone, allegedly giving rise to the expression 'Queen Anne at the front, Mary-Ann at the back'. Queen Square was constructed and financed through speculative building. This meant that whilst Wood designed the frontages and leased the land, each discrete plot was sublet to individual builders. They had two years grace in which to get the walls up and the roof on, after which they had to pay a more substantial rent. As Bath was booming, most plots were reserved before the two years was up, providing the builder with the necessary income to complete the house.

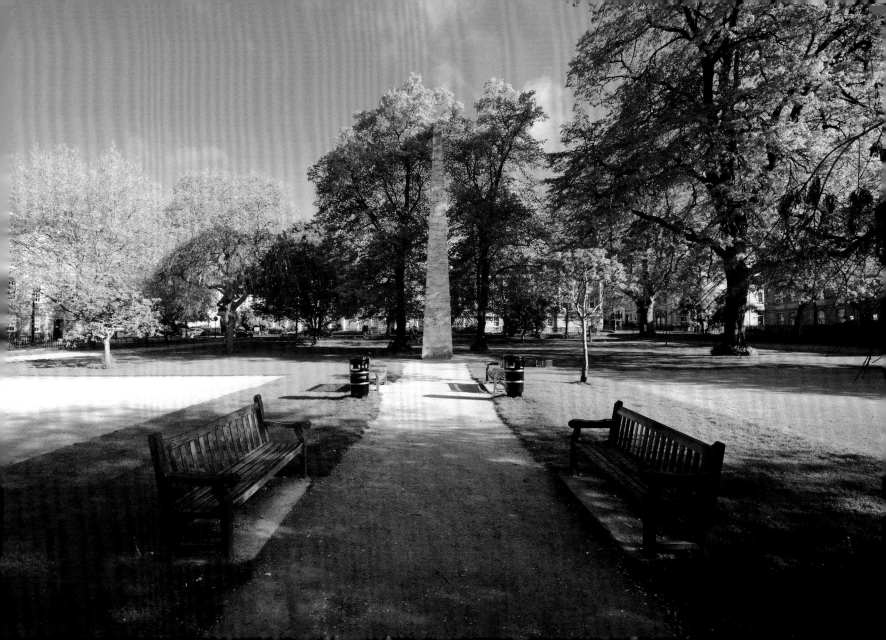

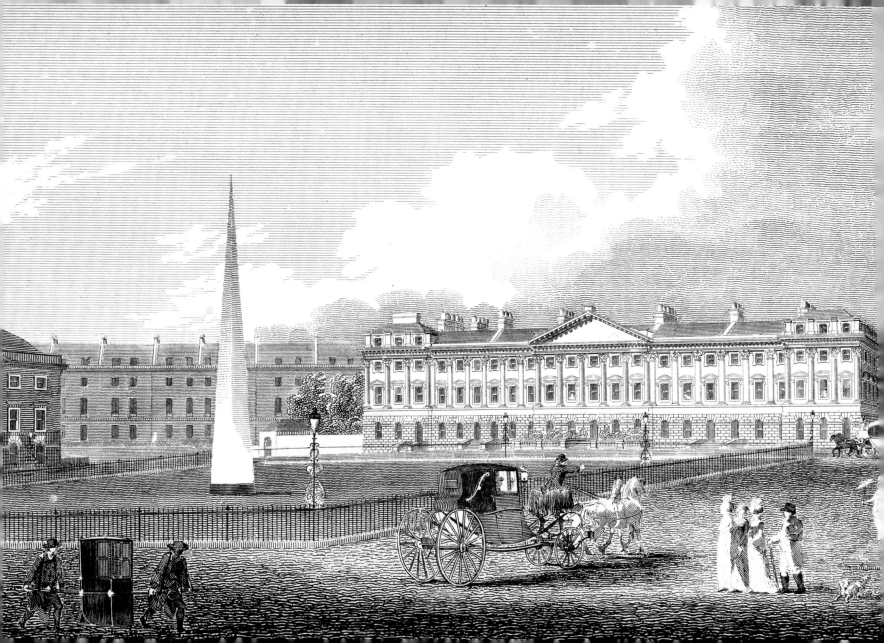

(facing) W. & G. Cooke, *Queen Square, Bath,* 1804, copper engraving

Wood wrote, 'the intention of a Square in a City is for People to assemble together'. Originally the central garden was divided by gravel into quarters with turf paths. The planting was low so Georgian society could promenade and check each other out!

In the centre is 'Nash's Ray' (right), erected by the Master of Ceremonies, Richard 'Beau' Nash, in 1738 as homage to Frederick, Prince of Wales (1707-51). It originally rose 70ft (21.3m), but a storm in 1815 put paid to the top.

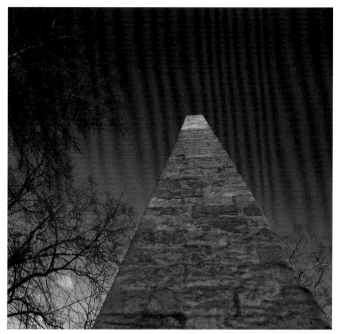

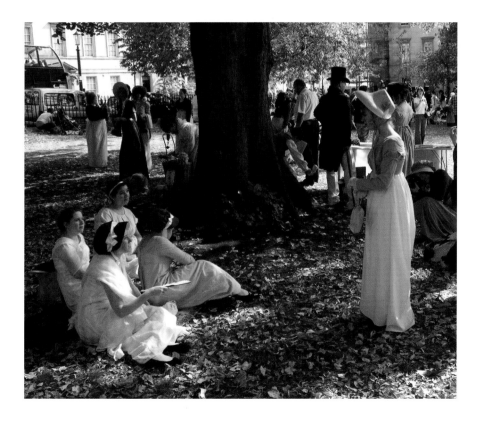

Since 2001, Bath has played host to The Jane Austen Festival (left). The highlight of this annual event is the Regency costumed promenade through the streets of Bath. In 2009, participants broke the Guinness World Record for the 'Largest Gathering of People Dressed in Regency Costume' with over 400 people taking part.

(facing) Mowbray A. Green, *37-41 Gay Street,* c.1903, photograph

Named after the landowner, Robert Gay, the street steps up the steep hill (right) and links two of John Wood's most important architectural set-pieces – the Circus and Queen Square. Originally Gay Street was only developed on the east side, up to George Street, but after 1755 John Wood the Younger built up both sides to make this the principal approach to the Circus.

By introducing speculative building Wood not only secured himself a fortune, he also shaped the entire city.

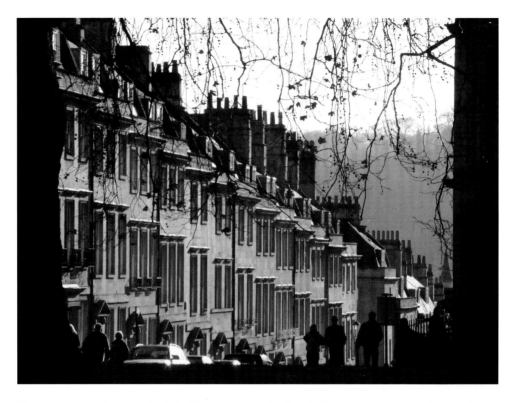

The rounded bay house is by John Wood the Elder and built for Richard Marchant between 1734 and 1736. Some histories say that Wood lived here himself, but he actually lived on the south side of Queen Square where the Francis Hotel now stands, perhaps so he could admire his architectural achievements in full. The Jane Austen Centre now occupies No.40 Gay Street; she lived at No.25 for a few months after the death of her father in 1805.

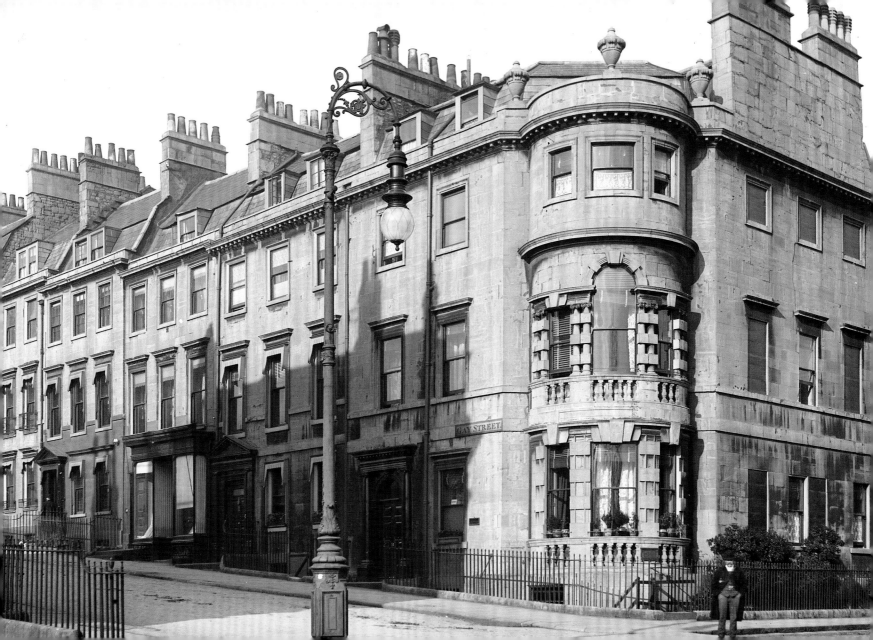

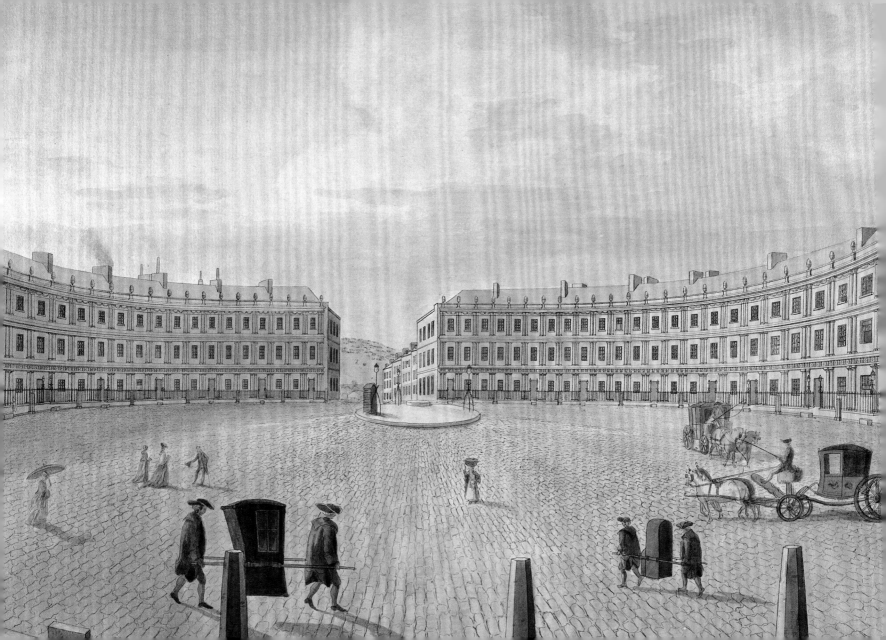

Throughout his career John Wood wished to construct a circular building. The Circus (1754-67) is the culmination of all of Wood's passions. It is here that he created a temple to the sun, taking influence and measurements from the ancient stone circles of the Druids – Stonehenge and Stanton Drew. The 525 metopes (below) on the Doric frieze are all different. No one has unravelled their meaning, but they are often seen as evidence of Wood's link with Freemasonry. Although there are similar elements, few of the complete emblems are recognised as Masonic.

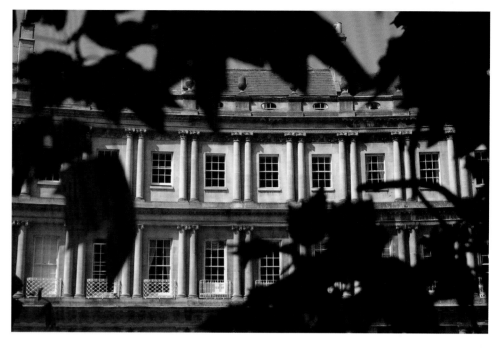

(facing) John Robert Cozens (1752-97), *The Circus*, 1773, coloured etching
At considerable expense, a terrace was sliced into Lansdown Hill to form a level base for the Circus. As you climb up Gay Street, still in admiration for Queen Square, you have no idea of the architectural awe you are about to experience as you step out into the Circus. Wood intended the Circus to be a paved open space, where the only natural element would have been the sky, leaving you in no doubt of the true genius of his creation.

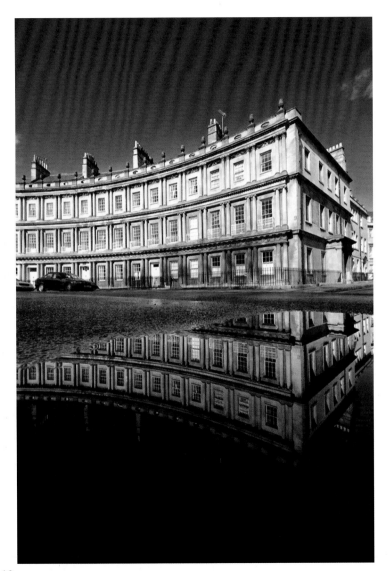

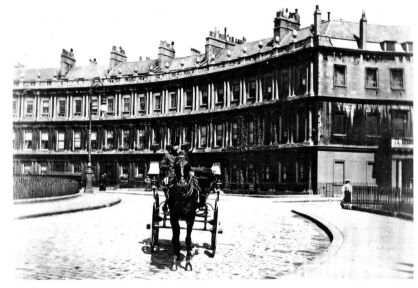

(above) *The Circus and Bennett Street*, c.1900, photograph

For Wood, Bladud was at the centre of the origin of building. He elaborated the legend, claiming that Bladud not only taught Pythagoras, but also was responsible for bringing the ideas of architecture to the ancient Druids, before founding Bath. By placing stone acorns around the parapet of the Circus, Wood was paying homage to Bladud (whose pigs were searching for acorns when they discovered the hot springs) and the Druids, who are also known as the Princes of the Hollow Oak.

The Circus (facing) was Britain's first circular street and has remained a sought-after address. In the 18th century residents included the artist Thomas Gainsborough and politician William Pitt the Elder. More recently, Hollywood actor Nicolas Cage made a home here. Sadly, Wood never saw the Circus complete; he died in 1754, three months after the foundation stone was laid. The task then fell to his son, John Wood the Younger.

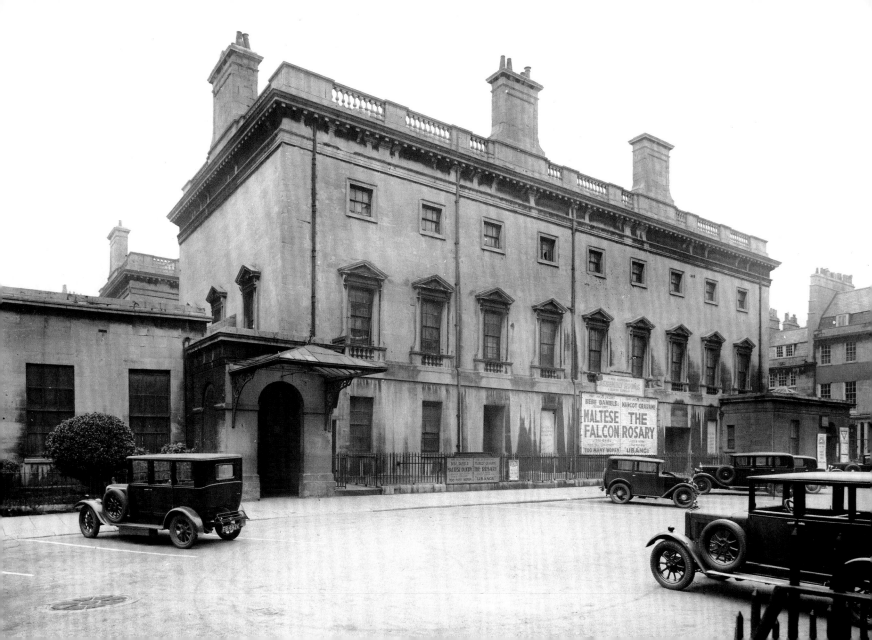

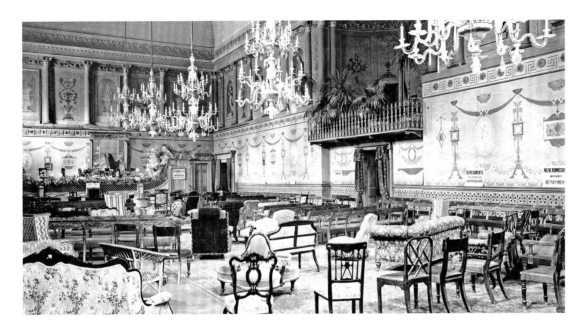

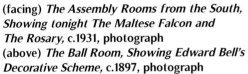

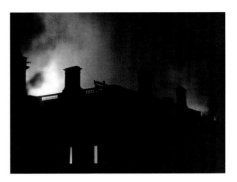

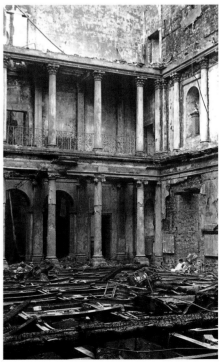

(facing) *The Assembly Rooms from the South, Showing tonight The Maltese Falcon and The Rosary,* **c.1931, photograph**
(above) *The Ball Room, Showing Edward Bell's Decorative Scheme,* **c.1897, photograph**

Designed (1769-71) by John Wood the Younger, the Assembly Rooms have experienced a varied fortune. At the height of the Woods' Upper Town success, these Assembly Rooms rivalled all other attractions in Bath. As Bath fell in popularity, this grand civic building struggled to find a purpose. It played host to public readings by Charles Dickens and concerts by Johann Strauss, before becoming a cinema for a while. Since 1963, the Assembly Rooms have also housed the Fashion Museum and its internationally renowned collection of fashionable dress.

(top right) *The Assembly Rooms Burning at the Height of the Raid,* **25 April 1942, photograph**
(bottom right) *The Burnt out Tea Room,* **April 1942, photograph**

In 1931, a grant from Ernest Cook allowed the Society for the Protection of Ancient Buildings to purchase the Assembly Rooms. SPAB gave the rooms to the National Trust who, in turn, rented them to the Bath City Council, restoring the building to its former glory in 1938. Tragically, on the night of 25 April 1942, the Assembly Rooms suffered a direct hit by enemy bombing completely gutting them, and a further restoration was required. The scorched pink exterior stonework, which can still be seen to the left of the entrance, is poignant evidence of the intense heat.

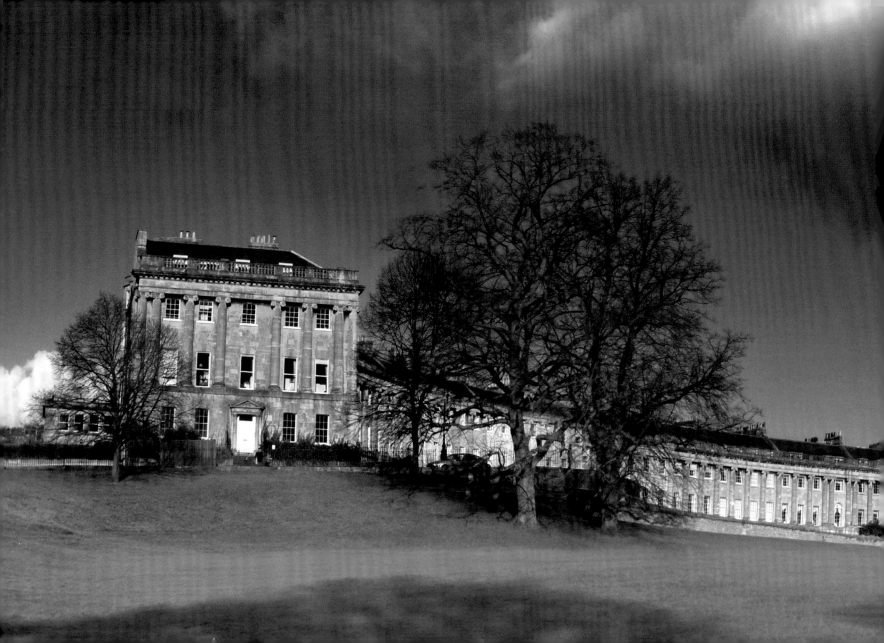

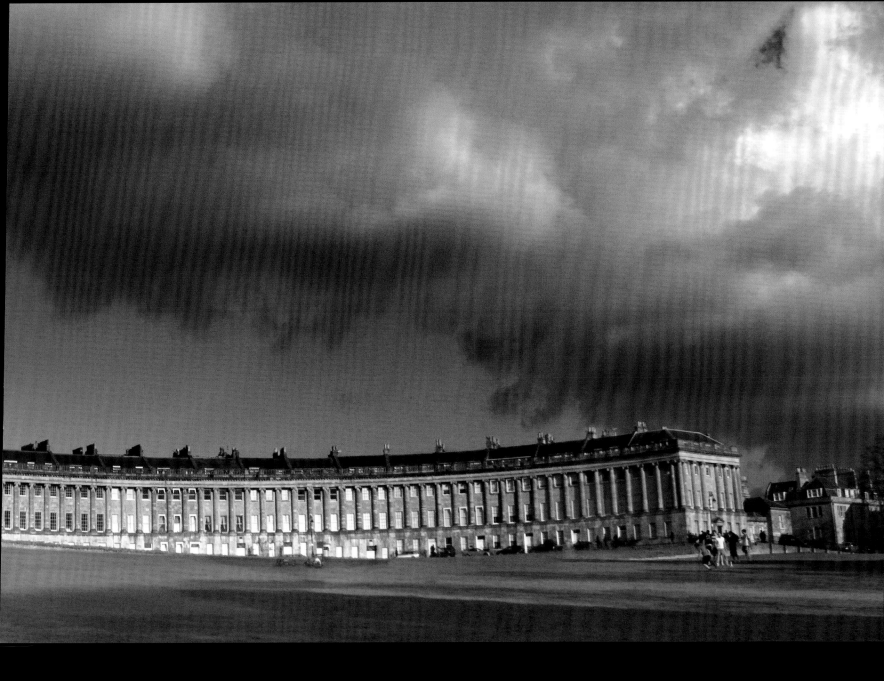

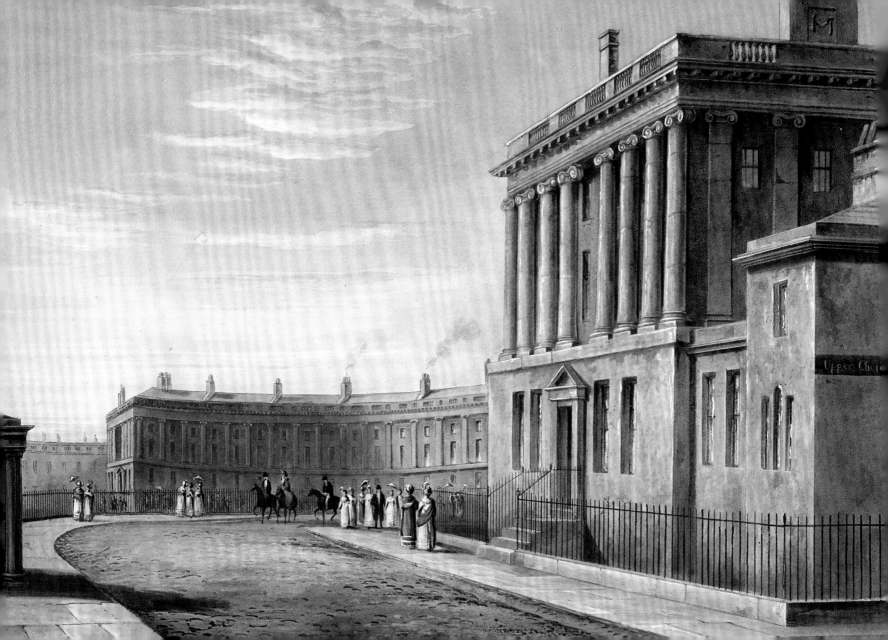

The Royal Crescent (previous), Wood's temple to the moon, is a spectacular feat of 18th century geometric engineering; a perfect half-ellipse of 30 houses with 114 giant Ionic columns. Conceived by Wood the Elder and built (1767-75) by Wood the Younger this was Bath's first crescent. Wood the Younger made clever use of the topography, adding to the dramatic impact as you round the corner after the sobriety of Brock Street. The Royal Crescent is a sweeping triumph of town-planning.

(facing) David Cox (1783-1859), *The Royal Crescent*, 1820, aquatint
In 1968, Major Bernard Cayzer purchased No.1 Royal Crescent and presented it to the Bath Preservation Trust, who restored the house using only materials available in the 18th century. Now one of Bath's leading museums, No.1 provides an opportunity for modern-day visitors to experience what life was like inside these elegant residences. Each room is an exquisite example of Georgian interior design with authentic furniture, paintings, and textiles.

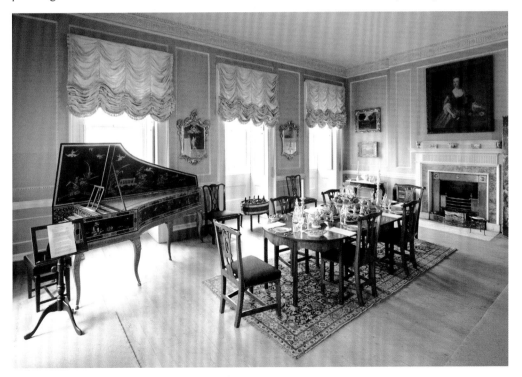

The beautifully appointed Dining Room (left) is set for the dessert course. By 1782, Bath's season extended from September through to May, but it was only fashionable to reside for up to six weeks. Visitors rented rooms or houses for the duration of their stay and No.1 is an example of the luxury accommodation available for the aristocratic visitors who came to Bath to take the waters and enjoy the social season.

(below) Cyril Howe, *Making Adjustments to the Bath Model,* c.1970, photograph

The impetus for the Bath model was to create an adaptable three dimensional tool to aid the planning process. This detailed scale model illustrates the incredible skill the model-makers had in rendering some of Bath's most important architectural set-pieces. The model, which is over ten feet (3m) square, was made in sections so that areas of Bath could be lifted out and new scale model sections put in to help illustrate the potential impact of any modern developments.

(facing) *Celebration of Peace, Royal Crescent* 19 July 1919, photograph

The open space in front of the Royal Crescent became a natural focus for crowds to gather and give thanks for the end of World War I.

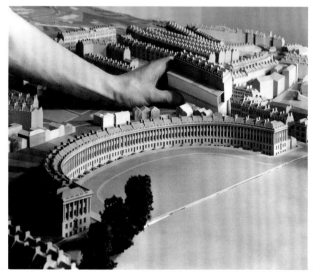

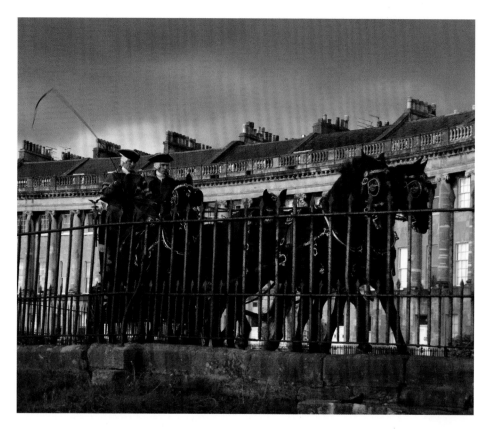

The retention of Bath's glorious Georgian architecture makes the city a popular backdrop for filmmakers. It is not surprising to find yellow lines hidden by dirt, and prop barrels and bales hiding parking meters, as a phaeton carriage, drawn by majestic horses and driven by wig and tricorn clad coachmen (above), quickens through Bath's heritage streets. In recent years Bath has played host to such blockbusters as *Vanity Fair* (2004), *Persuasion* (2006) and *The Duchess* (2007).

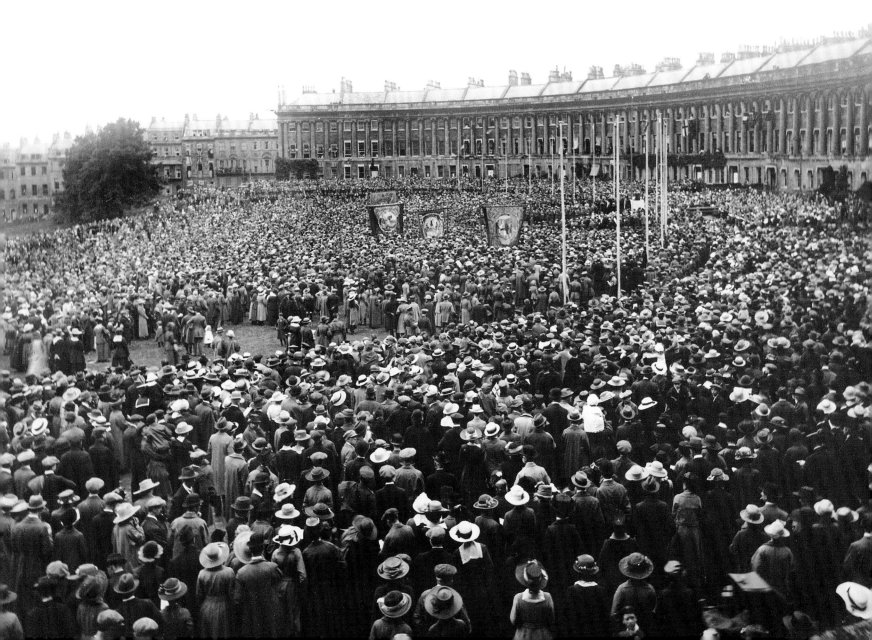

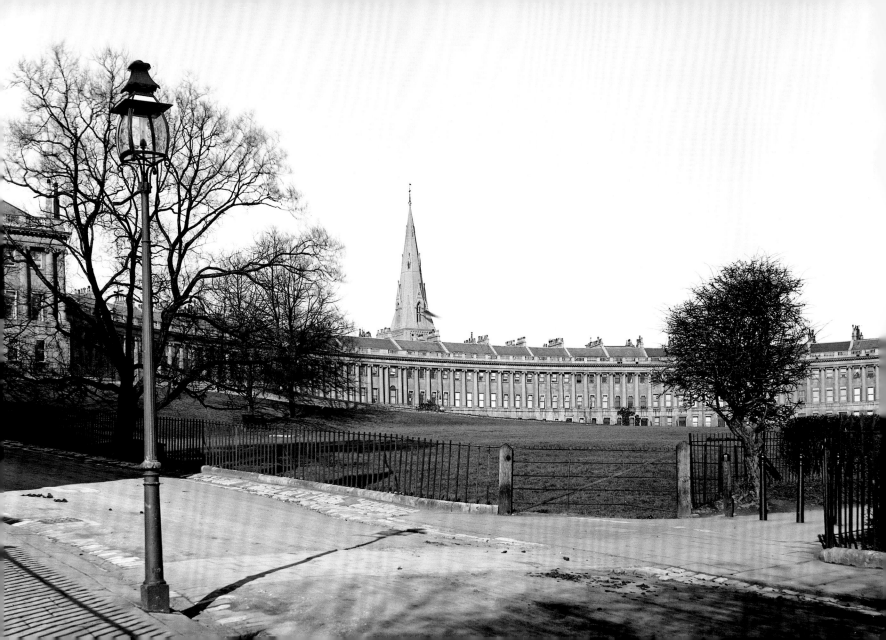

(facing) Mowbray A. Green, *Royal Crescent with the Spire of St. Andrew's Church behind*, c.1903, photograph

Between 1878 and 1942 the imposing spire of
St. Andrew's Church (1869-73) broke the skyline
behind the Royal Crescent. Designed by Sir George
Gilbert Scott, it was the tallest building in Bath.
The Gothic Revival St. Andrew's suffered a direct
hit during the Bath Blitz in April 1942 – a triangle
of grass, bounded by roads, marks its grave.
Finally cleared in the early 1960s, the rubble was
used in the nearby Church of St. Andrew (1961-4)
by Hugh D. Roberts.

When built, the Royal Crescent, surrounded
by fields, was a long way – geographically and
emotionally – from the historic centre of Bath.
Fortunately, Crescent Lawn (left) has been
retained, providing a private open space for the
residents. The lawn is divided from what is now
Royal Victoria Park by a ha-ha, quite possibly
the first urban use of this clever device that
does not block the view, but keeps the cattle
from straying.

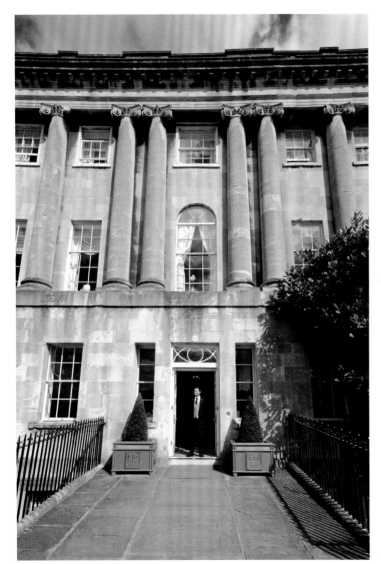

Marked by the coupled Ionic columns and first-floor arched window, the central building on the Royal Crescent is a luxury hotel (left), as it has been since it was built. Then solely for ladies visiting the resort, including social reformer and writer Elizabeth Montagu (1718-1800), now it welcomes all who can afford it. A surprising oasis, the hotel has far more facilities and grounds than one would imagine, including an exclusive spa and 'secret' gardens (facing) as two of its many attractions.

Uniquely, because of Bath's status as a health resort, Georgian women could legitimately travel here without their husbands. Bath was a much freer society than London, and women enjoyed their independence by openly drinking spirits, gambling and socialising. However, this situation did fuel Bath's reputation as being the centre of scandal and undoing. Richard 'Beau' Nash outlawed gossiping, but the Company overcame this by publicly posting anonymous poems satirising or rebuking individuals.

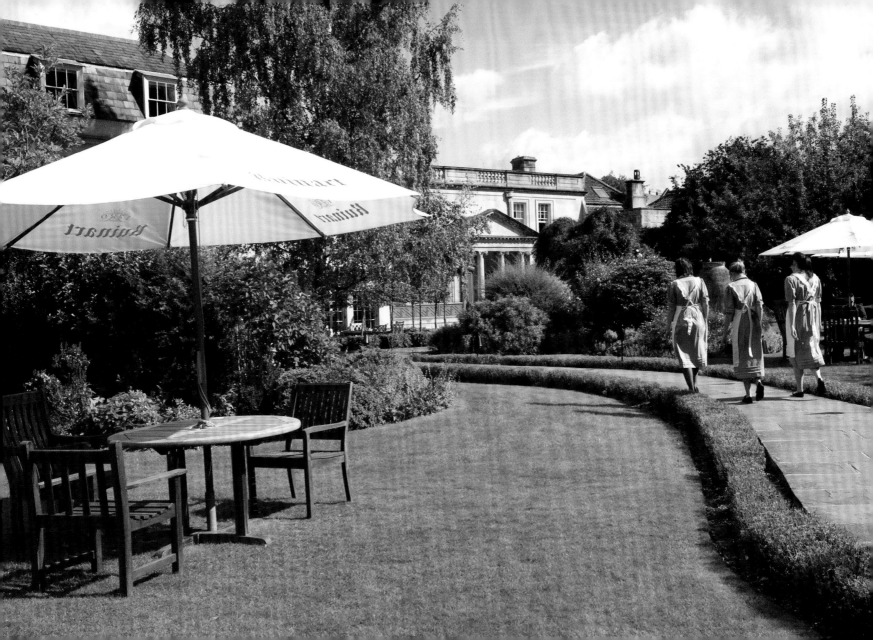

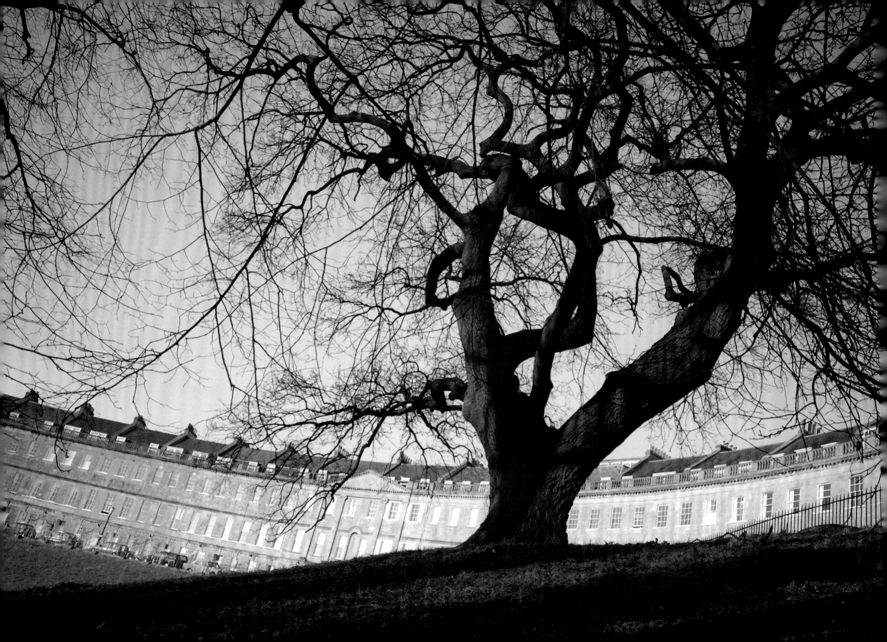

(below) *Lansdown Crescent,* **1860, steel engraving**

Built between 1789 and 1793, Lansdown Crescent (facing) is a favourite crescent with locals, probably because it is slightly off the beaten track and commands such stunning views. It was financed by Charles Spackman (1748-1822), who had made his fortune as a coachbuilder; he also dabbled in auctioneering and as a property valuer. The elegant serpentine crescent, originally known as Spackman's Buildings, was designed by John Palmer and built speculatively. It remains primarily residential and, remarkably, sheep still graze in the open fields below.

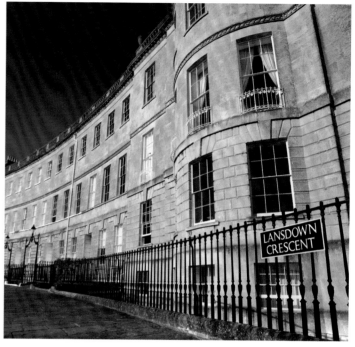

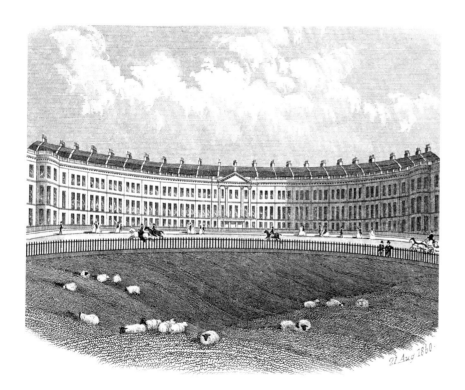

Lansdown Crescent comprises a central terrace of twenty houses, flanked by Lansdown Place East and Lansdown Place West. The crescent's most infamous resident was William Beckford (1760-1844) who, in due course, leased and owned Nos. 19, 20 and No.1 Lansdown Place West. In the 1820s he built a bridge to connect the last two properties and reputedly left No.19 empty to ensure peace and quiet.

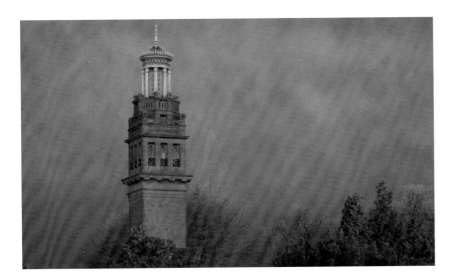

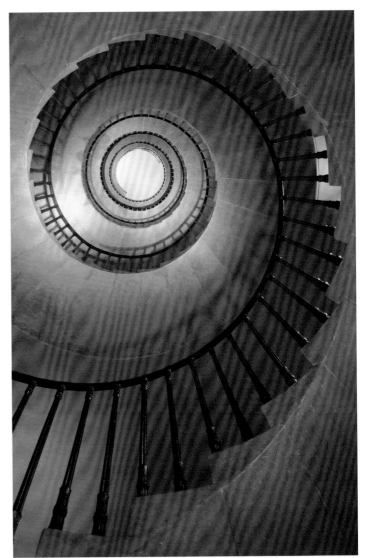

From his residence on Lansdown Crescent, the affluent Beckford leased and purchased land, leading from behind the crescent to the top of Lansdown Hill one mile away. It was here that he commissioned Henry Edmund Goodridge (1797-1864) to design him a retreat where he could study and house his precious collection of art and rare books. Completed in 1827, the 120ft (36.6m) neo-classical tower (above), which enjoys uninterrupted views of the surrounding countryside, is crowned with an octagonal lantern decorated with columns gilded in gold leaf.

(facing) Arthur Ashley (after J. F. Burrell), *Beckford's Tower and Tomb, Walcot Cemetery, Nr. Bath,* **c.1850, steel engraving**
After Beckford died, the tower and gardens were sold to a Bath publican. Beckford's daughter, the Duchess of Hamilton, was horrified to discover that her father's retreat was proposed to be used as a beer garden and promptly bought it back. The tower became a funerary chapel and the garden a cemetery, which houses Beckford's tomb. Since 1993, the Bath Preservation Trust has been sole trustee of Beckford's Tower. Open as a museum, visitors can follow in Beckford's footsteps and climb the spiral staircase (right) to the Belvedere.

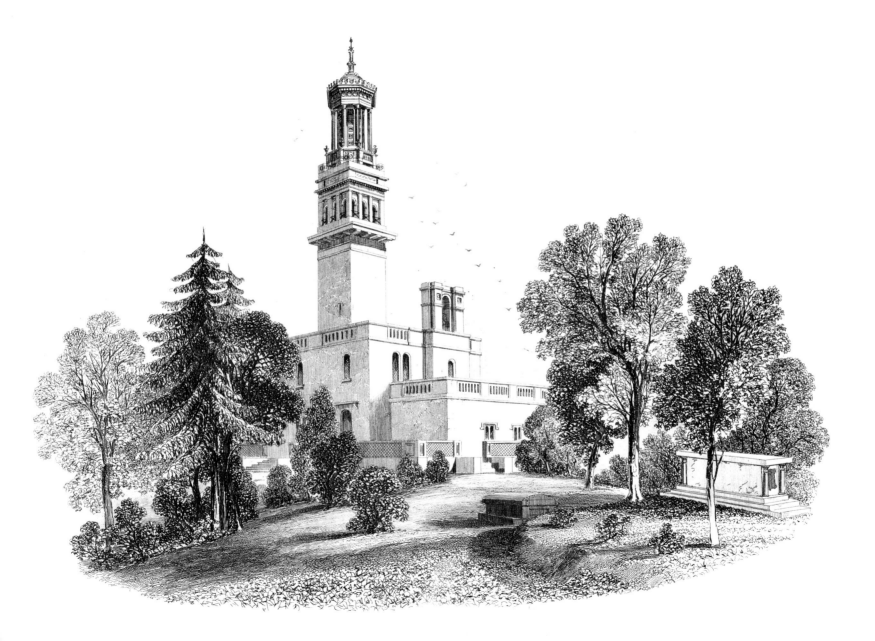

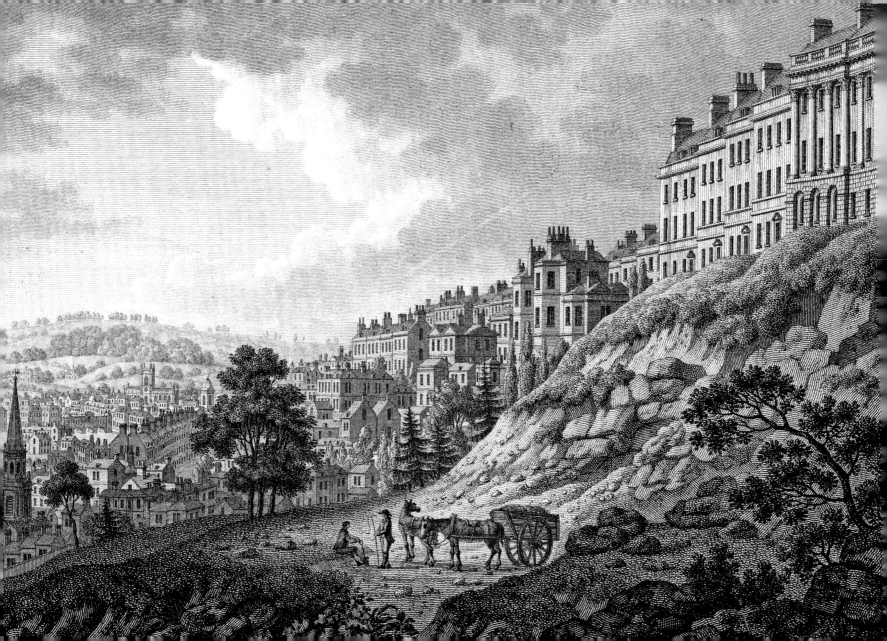

(facing) W. Watts, *Bath from Camden Place,* 1794, copper engraving
Camden Crescent (1787-8), as its name suggests, followed the then customary architectural fashion in Bath, but the choice of site was unwise. John Eveleigh (active 1780-1800) struggled with landslips, leaving the centre of his speculation off-centre with only four units to the right. The repeated elephant motif relates to Charles Pratt, first Earl of Camden (1714-94), Recorder of Bath from 1759 and Lord Chancellor between 1766-70. Although not the developer of Camden Crescent, Pratt was responsible for Camden Town, London.

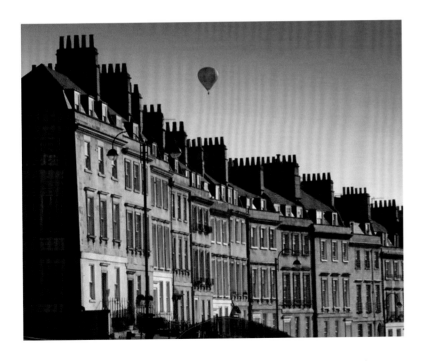

Below Camden Crescent is Hedgemead Park (above), created in 1889 after 175 properties were destroyed during a landslip in 1881. A delightful oasis above the London Road, Hedgemead Park is also a fine example of sturdy Victorian engineering. Beyond, on Bath's tallest raised pavement, is Walcot Parade (left, c.1770). Despite the initial look of uniformity, all the houses in this terrace are of different widths and heights and probably the result of a number of individual builders cashing in on the Bath building boom, as opposed to the vision of one architect-surveyor.

The classical St. Swithin's Church (below, 1777-80) is situated at the junction where Walcot Street and the Paragon meet the London Road. Designed by Thomas Jelly and John Palmer, St. Swithin's has seen a number of important historical events, including the marriage of Jane Austen's parents (Rev George and Cassandra Leigh) and the marriage of William Wilberforce and Barbara Ann Spooner. The artist Thomas Robins was buried here, and the tombs of novelist Fanny Burney and Jane Austen's father are visible in the grounds at the apex of the site.

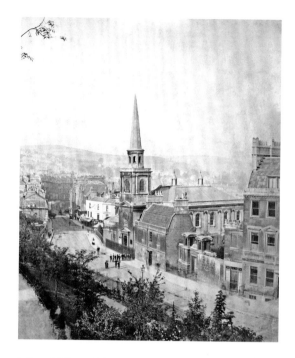

(above) *View of St. Swithin's Church from Hedgemead Park,* **1896, photograph**
The panoramic view north-east (facing) shows the tower of George Phillips Manner's St. Michael's Church (1834-7), the gentle sweep of the Paragon (1768-75) by City Architect Thomas Warr Atwood (c.1733-75), the green space of Hedgemead Park and behind the asymmetrical Camden Crescent.

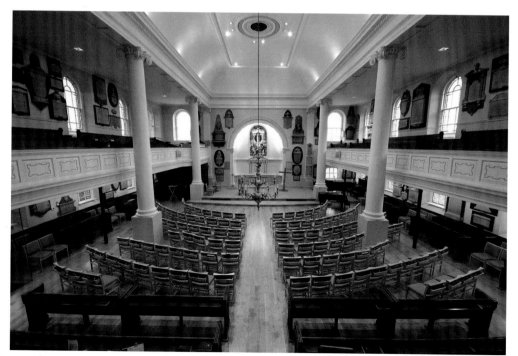

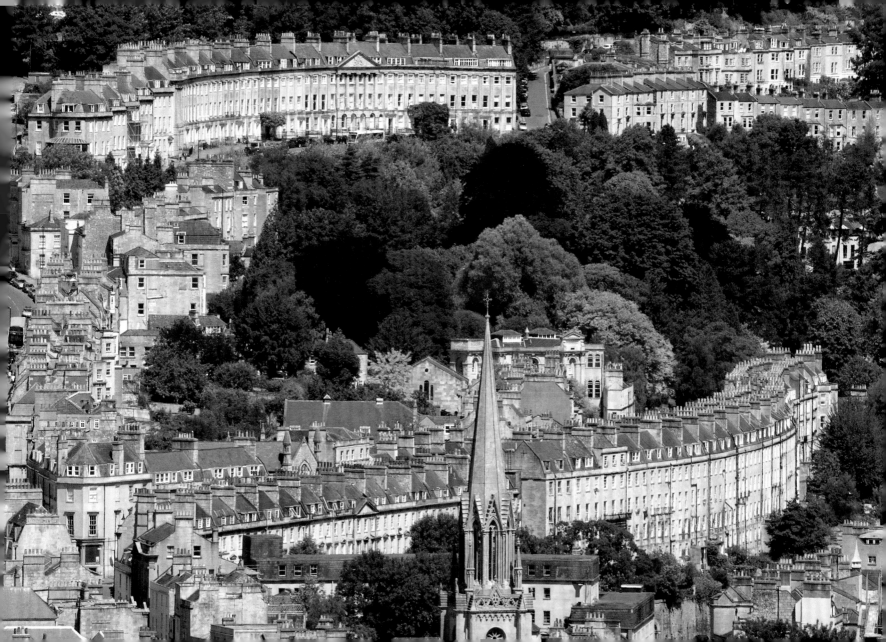

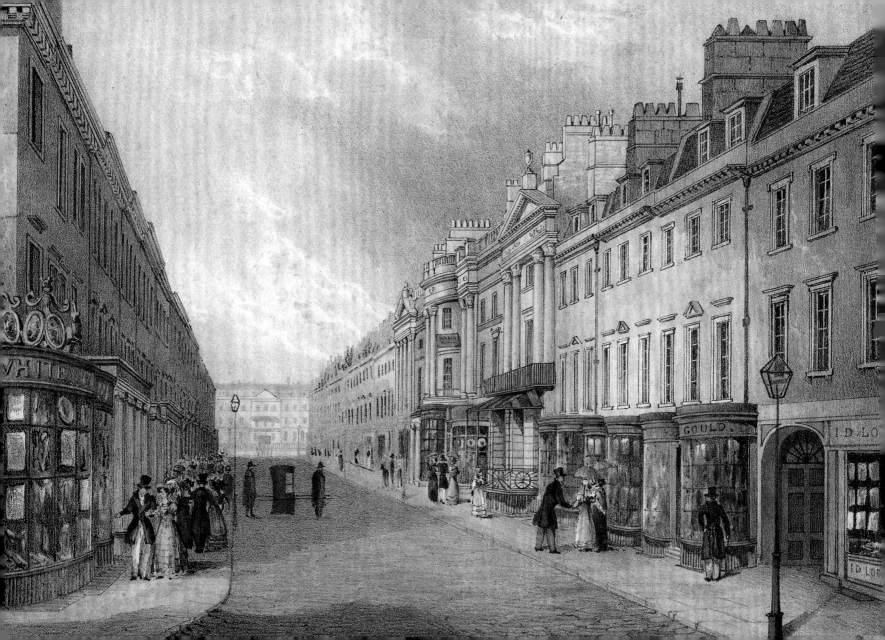

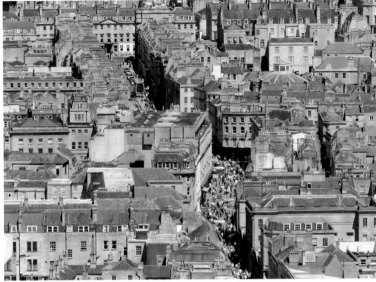

(facing) W. Gauci (after A. Woodroffe), *Milsom Street,* **1828, lithograph**
Bath is a mecca of shops offering a wide range of quality goods. Many of the finest retailers are still found on Milsom Street, just as they were in the 18th century.

Landowner Daniel Milsom attempted to develop the land in 1746 and again in 1753, but it was his son Charles who successfully pushed the project forward from 1761, in partnership with the Corporation. The shops in Milsom Street step up gradually and in so doing visually diminish the steepness of the climb.

The presence of a poorhouse on the east side hampered progress, but the site was eventually cleared in 1780 and developed as Somersetshire Buildings between 1781 and 1783 by Thomas Baldwin. Milsom Street was intended as a link between the centre of Bath (around the Abbey and Baths) and the ever growing and fashionable Upper Town. Jane Austen famously used Milsom Street as the residence of General Tinley in *Northanger Abbey*.

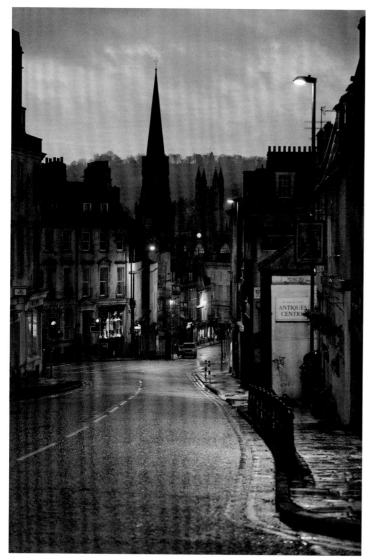

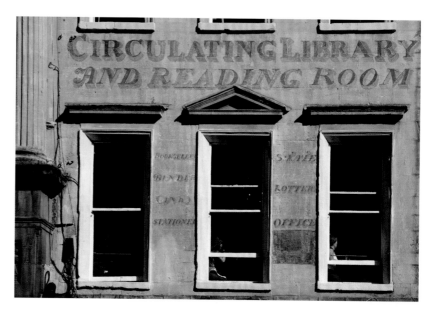

Viewed from Lansdown, the tall spire (left) of St. Michael's was originally a medieval church; this version is by George Phillips Manners. Unlike much of Bath, Broad Street retains a number of medieval features and buildings. Although many are lost behind the Georgian façades, details can still be found. Broad Street was one of the first 'suburbs' developed beyond the old city walls, with known deeds dating back to the 13th century.

Visiting one of the libraries was an important part of the day for the Company. By the end of the 18th century, Bath could boast sixteen circulating libraries with reading rooms (above), which was of huge significance for an increasingly literate middle class.

(facing) *Luxury Motorcars outside Jolly's, Milsom Street*, c.1925, photograph
By the mid-19th century, retail was Bath's largest employer. James Jolly and his son Thomas opened their flagship department store The Bath Emporium in 1831. Extended in 1834 and again in 1879, it now occupies Nos. 7-14 Milsom Street. The interior of Jolly's still has remnants of Victorian and Art Nouveau detailing.

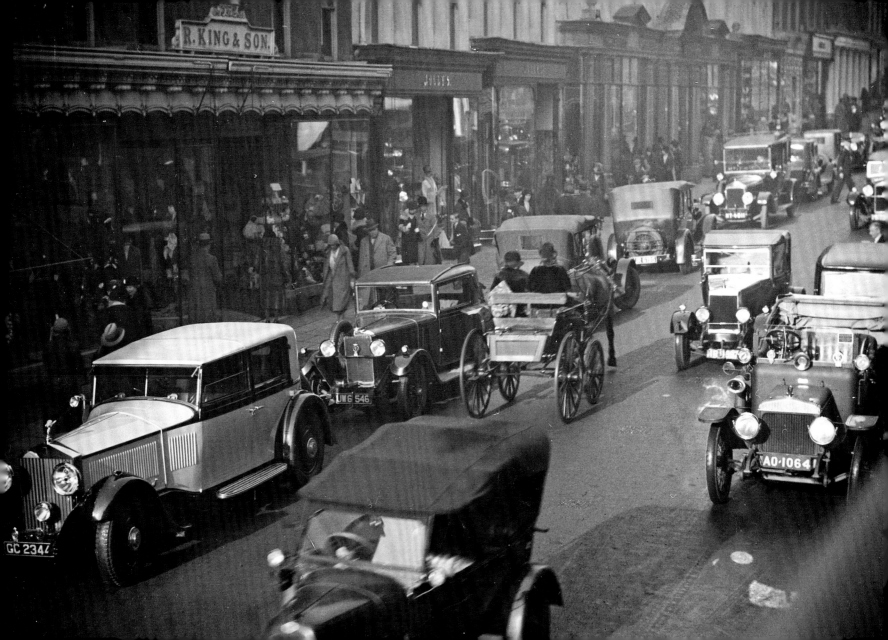

(below) *The Sham Castle*, wood-engraving from James Tunstall's *Rambles about Bath, and its Neighbourhood*, 1848

Built as a fashionable eye-catcher by Ralph Allen c.1762, Sham Castle (facing) shows off the qualities of Bath stone, but it is merely a façade. Reputedly built so Allen could view it from his townhouse in Lilliput Alley, it was also perfectly positioned on the Claverton Down hillside, opposite the hub of Georgian social life played out at Parade Gardens, Harrison's Walk and the two assembly rooms.

The gorgeous honey coloured Bath stone is an oothilic limestone. According to John Wood, opponents considered it unable to bear any weight and like 'Cheshire cheese, liable to breed maggots that would soon devour it'. Bath stone is soft, but this makes it easy to carve delicate decorative details. Once exposed to the atmosphere it forms a natural hard, protective crust. The best quality stone is sawn into smooth rectangular ashlar blocks and used for the façades. The poorer quality rubble stone is used for rear walls, infill or burnt to make lime for mortar.

Sir Jeffry Wyatville (1766-1840), architect to George IV, designed the spectacular neo-classical Claverton Manor (below). With its commanding views over the Limpley Stoke Valley (a designated area of outstanding natural beauty) this building was begun in 1820 to replace the old Jacobean manor in Claverton village. Between 1874 and 1958, the Skrine family of Warleigh Manor owned this splendid house. In 1897, Henry Duncan Skrine played host to Winston Churchill whilst he made his first political speech at Claverton Manor, an event now commemorated by a plaque by the manor's front door. In the late 1950s, two Americans, Dallas Pratt and the British-born John Judkyn, were looking for a location in which to open a museum dedicated to American decorative arts. Claverton Manor was ideal. The founders wanted to share their passion for American culture beyond the Hollywood myth and to foster a greater understanding between the two countries.

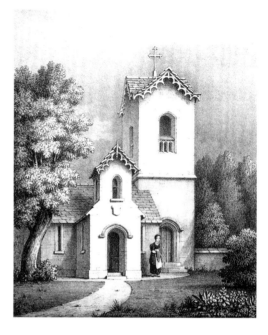

(above) H. Worsley, *Gate Keeper's House, Claverton*, after 1828, lithograph
The American Museum in Britain opened in 1961. The manor, extensive grounds and unique collection were a gift to the people of Britain as a symbol of the special relationship. Half a century on, the founders' message is kept alive with an exciting and diverse series of American themed events (facing), live music, courses and exhibitions that complement the period room displays. The American Museum is the only museum dedicated to Americana outside the United States.

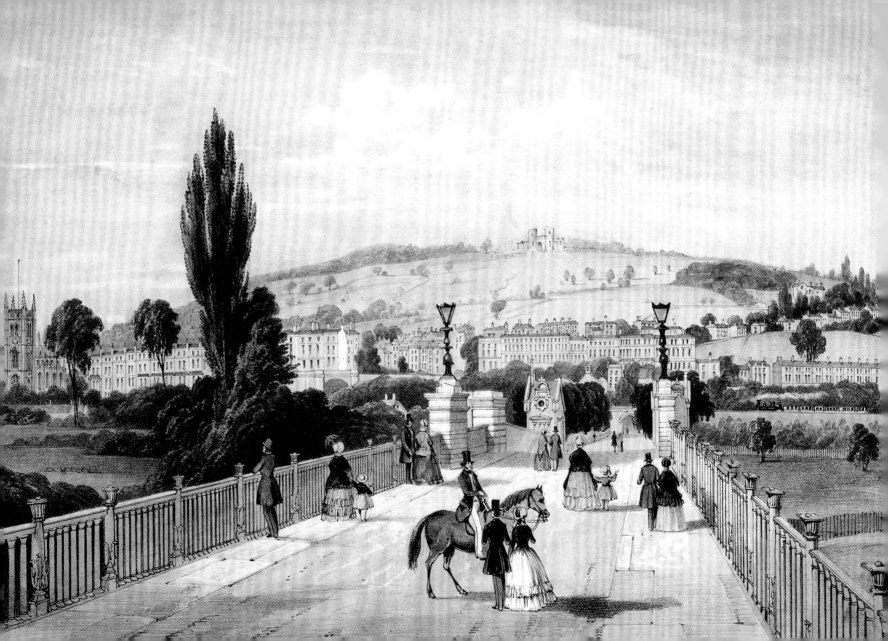

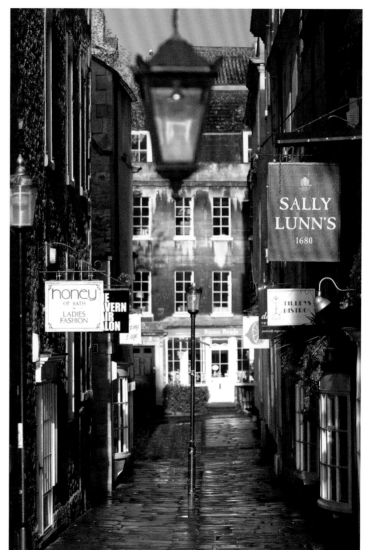

(facing) J. Newman, *Sham Castle from the North Parade Bridge*, c.1850, lithograph

Since the Romans, Bath has had an international reputation as an important place to visit. Then they came to pay homage and take the waters, later they came to gamble, dance and still take the waters. Today, more than four million visitors a year come to Bath for the unique experience this beautiful city has to offer. The enviable lifestyle and atmosphere, the awe-inspiring architecture and setting, and the important stories told by the city's outstanding heritage attractions all combine to make a visit to Bath unforgettable.

(below) *View down Church Street into Abbey Green*, **c.1910, photograph**

Abbey Green (right) was once the site of the old Priory precinct. On the dissolution of the monastery in 1539, it was sold to Humphrey Colles. The thirteen houses range in date from the 17th century to the early 18th century, the earliest being developments by John Hall of Bradford-on-Avon who purchased the land in 1612. The square has a much older feel than other areas in Bath, probably because it has retained its cobble setts. The large London Plane tree was planted c.1790.

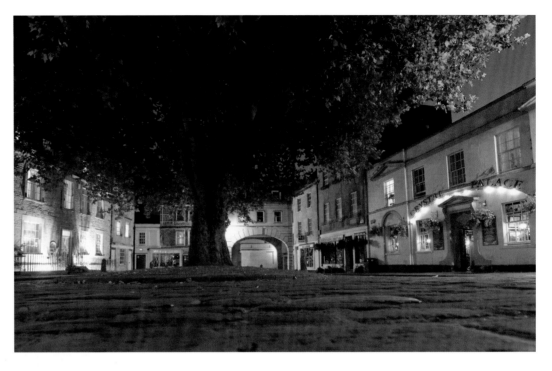

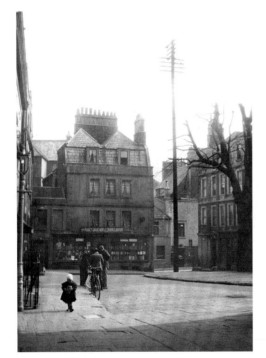

(facing) *Looking towards Abbey Gate from Abbey Street, before construction of St. Michael's arch,* **c.1920, photograph**

After John Wood's development of the nearby Parades (1740-8), where he built the townhouses on 18ft (5.5m) high vaulted foundations capped with 50ft (15.2m) wide pavements, the level of Abbey Green had to be raised to conform more seamlessly. The current ground floors were originally the first floors. This is more apparent when you look at the level of Lilliput Court to the rear of No.2 Abbey Green.

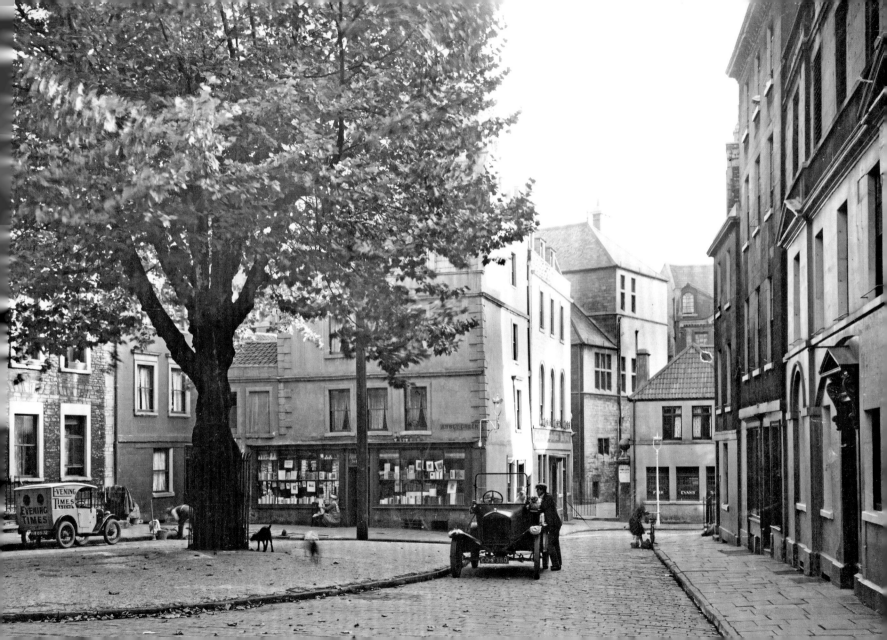

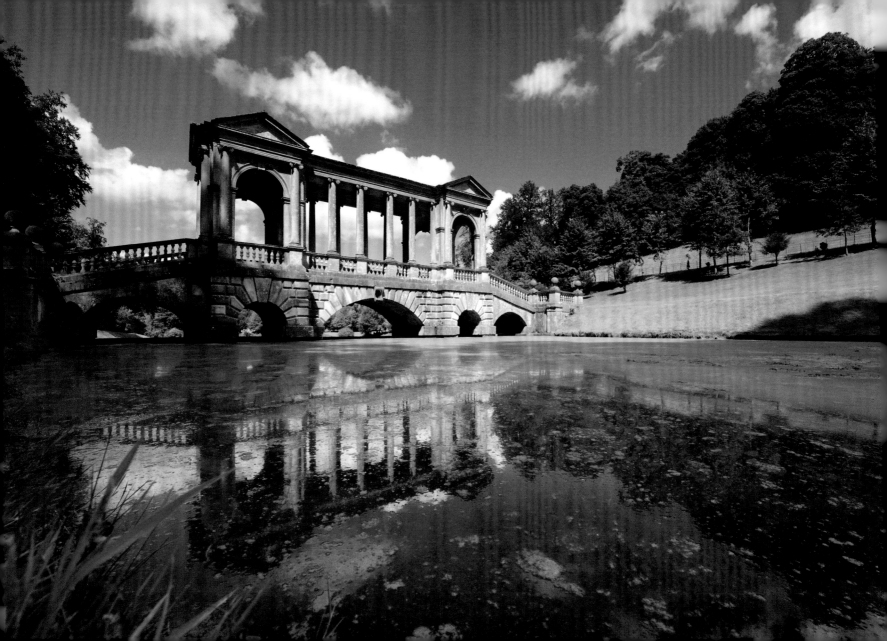

(below) J. Hollway, *Prior Park on fire, as it appeared on the evening of 30 May 1836,* lithograph
Built between 1734 and 1741 as a huge advertisement to the qualities and versatility of the local Bath stone, Prior Park became a tourist attraction with visitors interested in catching sight of one of the Georgian 'celebrities' – such as poet and garden designer Alexander Pope, or authors Henry Fielding and Samuel Richardson – who were regular guests of owner and entrepreneur Ralph Allen. The landscape was created with advice from Pope and later by Lancelot 'Capability' Brown (1716-83).

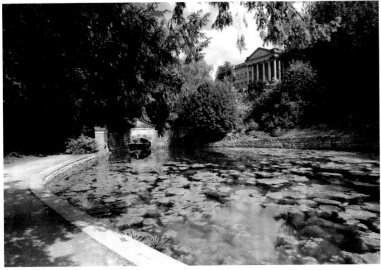

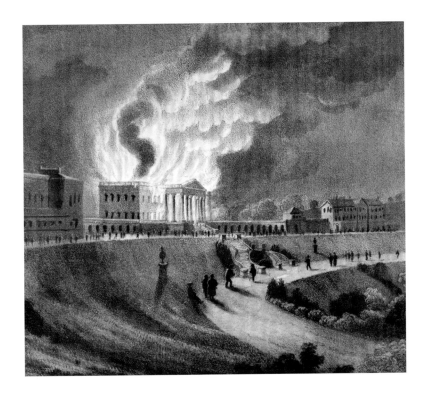

Prior Park gardens were extremely fashionable, with exotic features such as a Gothic cottage and Chinese gates. The Palladian Bridge (facing) was built in 1755 and is one of only four in the world (the others are Stowe, Wilton and St. Petersburg). Tragically, Prior Park has suffered from two devastating fires, in 1836 and 1991.

Prior Park mansion is now a Roman Catholic school, whilst the gardens have been owned by the National Trust since 1993. In 2005, the National Trust began a major grant-aided project to renovate areas in the grounds, including Pope's wilderness, the serpentine lake (above) and the cascade.

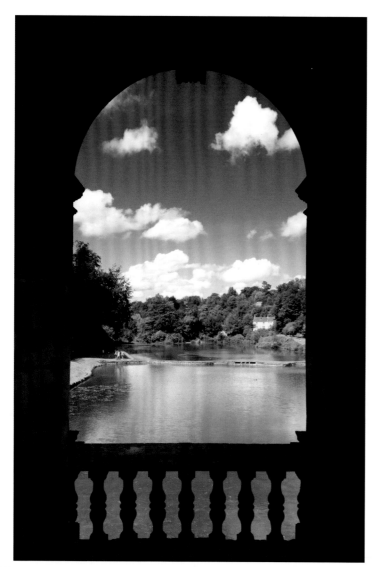

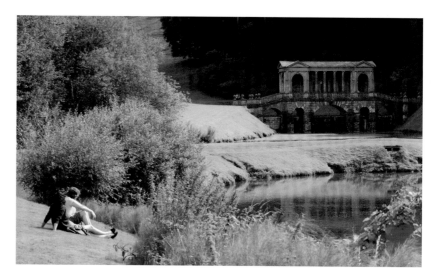

Ralph Allen's rags-to-riches story is akin to Bath's own. Born in Cornwall, Allen came to Bath and rose to the position of deputy postmaster. He made his fortune by reforming the postal service, creating a network of postal routes that did not pass through London, which helped significantly reduce the innate fraud and inefficiency. Allen invested his newfound wealth in the stone quarries and the navigation of the River Avon. He became an important member of the local business community and Mayor of Bath in 1742. An early patron of John Wood, Prior Park was built mostly to his design.

(facing) Anthony Walker (1726-65), *Prior Park, the Seat of Ralph Allen Esq. near Bath*, c.1750, copper engraving During the 18th century, also known as the Age of Enlightenment, visitors to Bath were fascinated by the technology Allen introduced to improve stone production. A significant early example of this is the tramway run on metal-flanged wheels and a crane to move the stone from his wharf to the barges. By 1750, Allen responded to this interest in his home and opened the grounds on Thursdays. He also introduced a garden centre, where you could purchase your very own fashionable garden statue in Bath stone.

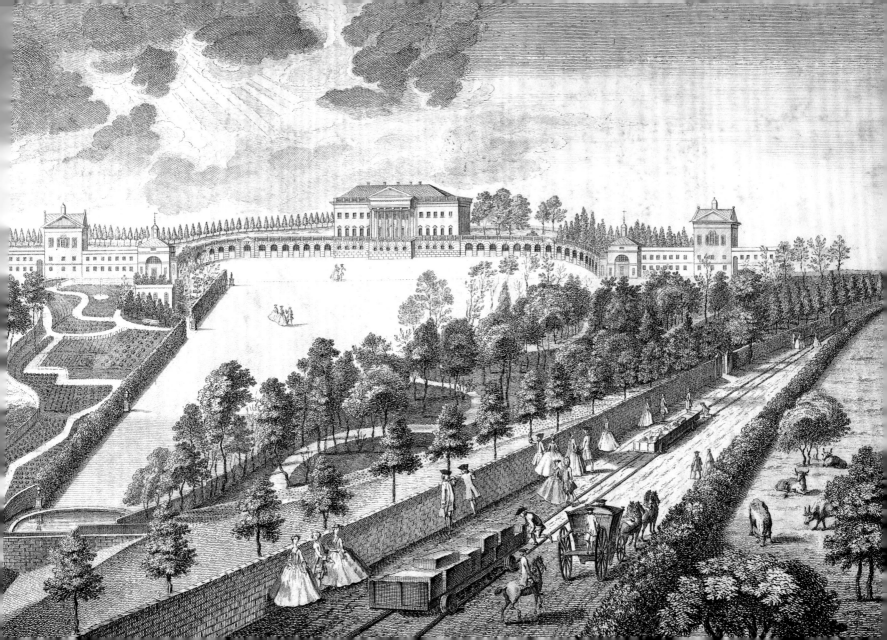

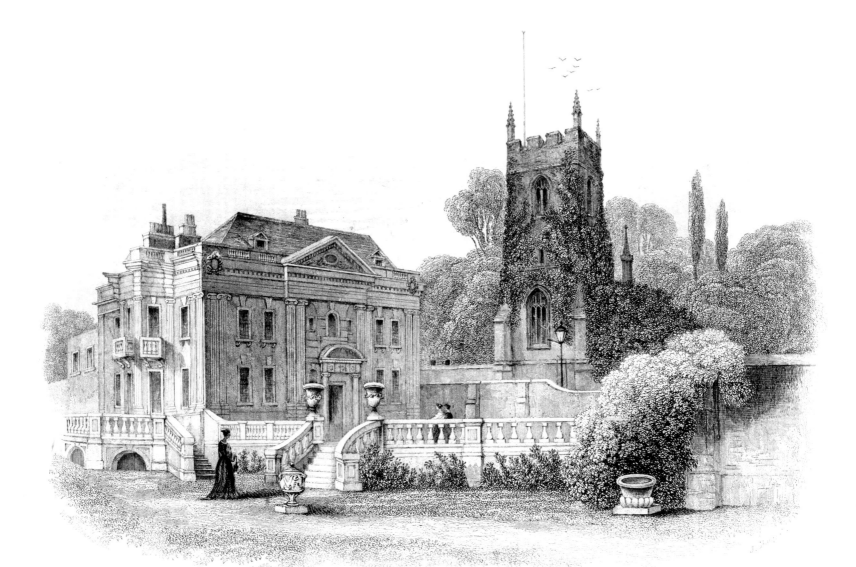

(facing) J. Shury (after W. Williams), *Widcombe, Old Church and House*, c.1886, steel engraving

Perhaps surprisingly Bath has few grand medieval manor houses. This is partly due to large tracts of land being owned by the church, the topography of seven steep hills and corresponding combes, and that the surrounding towns and villages were actually far more prosperous than Bath itself. Widcombe, to the south of Bath and across the River Avon, was part of ancient Crown lands and a separate parish to the city.

Widcombe Manor was probably built c.1656 by Scarborough Chapman, and it is of local legend that he employed Inigo Jones to undertake the design. Sadly there is no evidence that such an important architect is responsible. Nevertheless, it is an impressive building. In the early 18th century a descendent of Chapman, Phillip Bennet II, renovated the south front, later adding heraldry in commemoration of his two wives, both of whom died tragically young. The church of St. Thomas à Becket was built (1490-8) by Prior Cantlow. The octagonal dovecote (right), in the original grounds of Widcombe Manor, is 18th century.

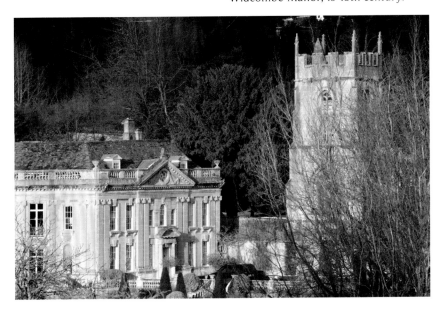

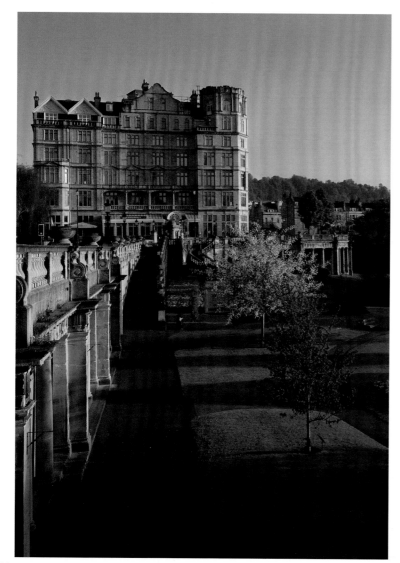

The site of Parade Gardens was originally the Abbey Orchard. In 1708, Thomas Harrison built Bath's first purpose-built assembly room on Terrace Walk. Areas bordering the orchard and the river were laid out as gardens and paths by Harrison for his clientele. The land sloped down towards the Avon and was liable to flooding. When the site was fully developed by John Wood as the Parades (1740-8), he had to introduce two-storey foundations in order to provide a flood-free and level building plot.

(facing) *North Parade Bridge*, c.1895, photograph

Major Charles Edward Davis introduced the robust colonnade (left) as part of his road improvement and Empire Hotel scheme (1895-1901). His new road system ran along the Avon, between Orange Grove and Bridge Street. Davis extended over Parade Gardens with the colonnade, thus creating the wider Grand Parade roadway we have today. Engineer W. Tierney Clark designed North Parade Bridge in 1835-6. It was made of cast iron and only clad in Bath stone by City Engineer F. R. Sisson in 1936-7.

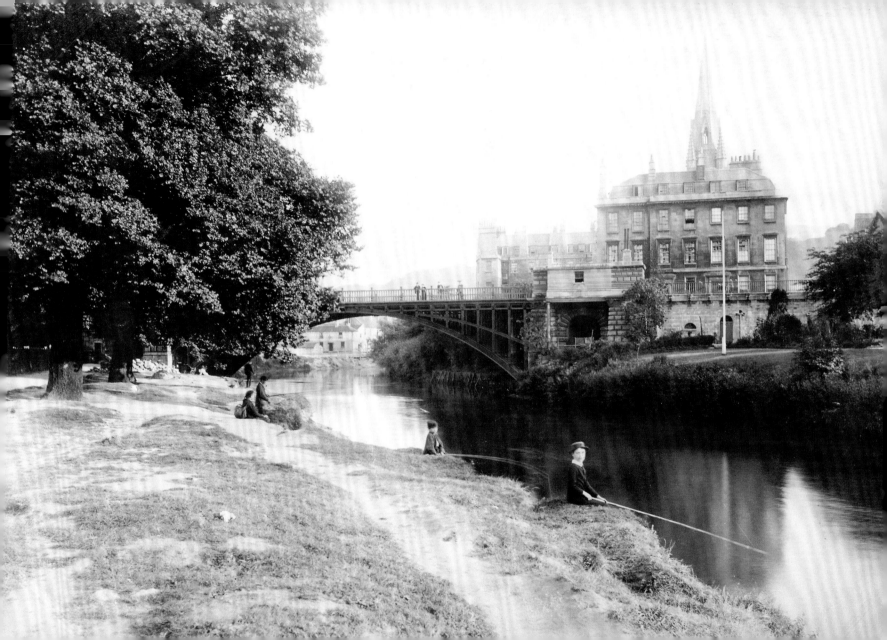

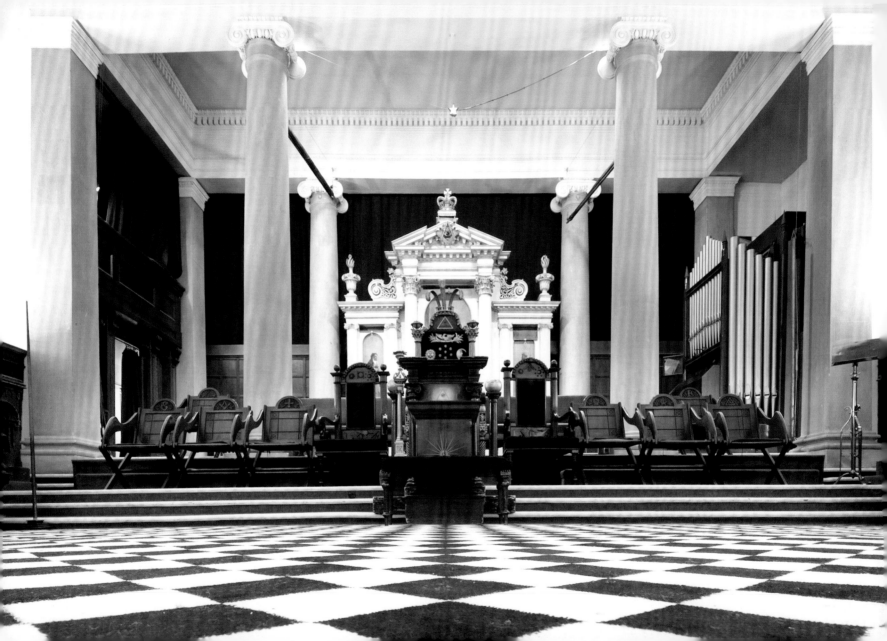

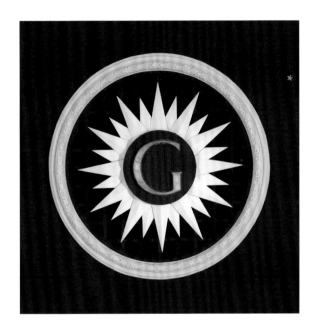

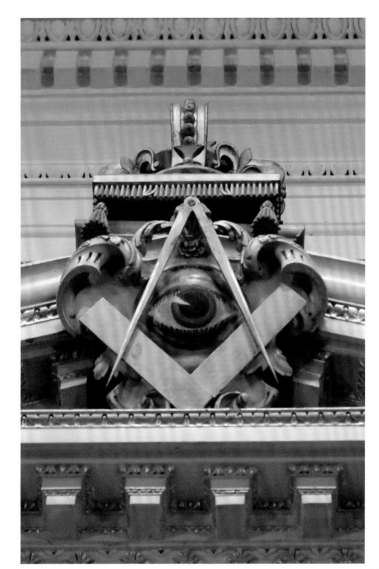

Freemasonry is an ancient secular fraternal society, with community, charity and tolerance at its heart. Bath has a long Masonic tradition, dating back to at least 1724 (with minutes preserved since 1732). Although actually very open about their beliefs and traditions since the 18th century, Freemasonry still has the reputation as being secret and mysterious. Members of the Bath Lodges have worked hard to dispel this myth and have now opened the Temple on Old Orchard Street

(facing) to prearranged group visits. Freemasonry is dominated by symbols; probably the most familiar is the 'all-seeing eye' or the Eye of Providence (right), set within a triangle comprising a square and compass. This is commonly interpreted as the eye of the Supreme Being, representing a belief in a great architect of the universe which is not necessarily a Christian God. In some instances (above left) the eye is replaced by the letter G, standing for the Great Architect, God and Geometry.

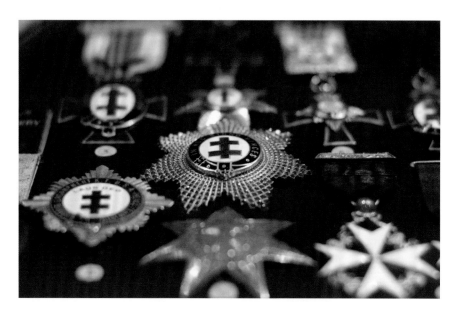

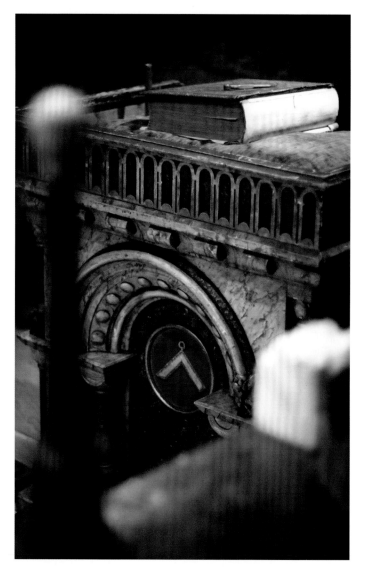

Bath's Masonic Hall has been housed in the Old Theatre Royal on Old Orchard Street since 1866. The theatre was built in 1750, probably by Thomas Jelly and added to by John Palmer in 1775. In 1768 it was the first theatre outside London to receive its Royal Warrant. The amazing career of Sarah Siddons (1755-1831) was made here; unable to win support in London she came to Bath and performed during four seasons (1778-82). Her greatest success was as Lady Macbeth, after which she was proclaimed Britain's greatest tragic actress.

(facing) T. Woodfall, *Bath's First Theatre Royal*, 1804, aquatint
In 1804, plans for a new, larger and better-equipped theatre in Beaufort Square led to the Orchard Street theatre closing in 1805. It was converted into a Roman Catholic chapel in 1809. In 1817 Bishop Baines (1787-1843) was appointed to the mission at Bath. A great orator and promoter of Catholicism, Baines was an important protagonist during Catholic Emancipation.

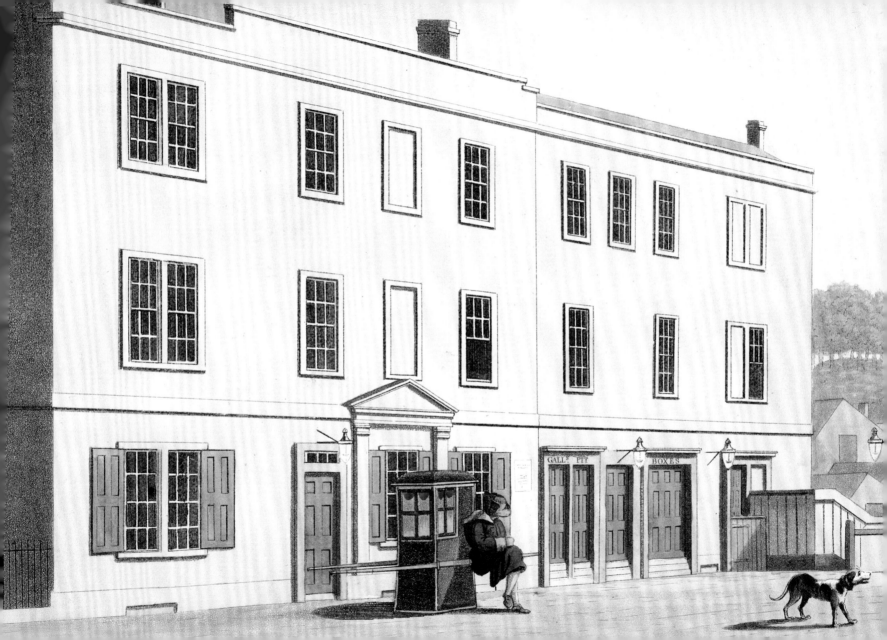

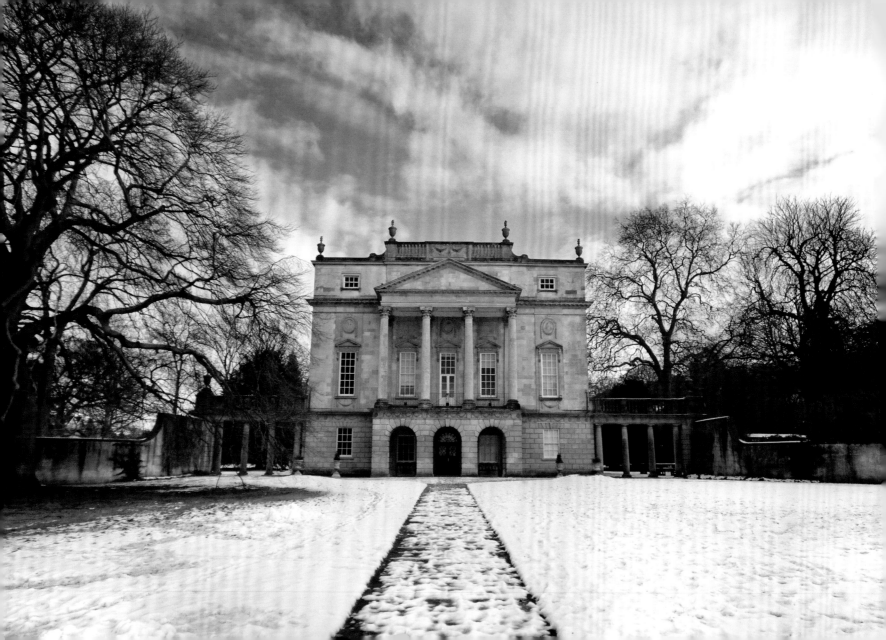

(below) *Sketch of the Fancy Fair at Sydney Gardens, Bath*, c.1840, lithograph

Standing majestically at the end of Great Pulteney Street is the Holburne Museum (facing), originally Sydney House (1796-7). Built by Charles Harcourt Masters (b.1759) as the focus and entrance for the pleasure gardens beyond, it contained coffee, tea and card rooms. In the basement was the Sydney Tap, a public house for the sedan chairmen (the equivalent of our taxis). Sydney House was converted by Sir Reginald Blomfield (1856-1942) and opened as the Holburne Museum in 1916.

(right) *Children of Bath*, flyer promoting a gala at Sydney Gardens on 11 September 1845

Sydney Gardens was established in 1795 as a fashionable pleasure garden. In 1819, writer Pierce Egan described the gardens as 'one of the most prominent, pleasing and elegant features' of Bath. The gardens boasted so many features and distractions that they were easily comparable to the pleasure gardens in London, such as Vauxhall and Ranelagh. Sydney Gardens was planted with exotic trees and shrubs, had well maintained gravelled pathways and offered supper boxes, music, singing, fireworks, illuminations, cascades, a labyrinth and a swing.

CHILDREN

OF

BATH,

Worry your Mothers to allow your Fathers to take you to SYDNEY GARDENS, Next Thursday, 11th September—Great Doings there—and all for A SHILLING. The Last Gala.

Promise them you won't be naughty for at least a week. Such beautiful Fire Works, you can't think—and such Illuminations, and Fire Balloons, and Funny Songs; and you'll see Naples, with the Burning Mountain of Vesuvius; and London by Moonlight—and the grand Railway, where they travel almost Fifty Miles an hour—and the great Fire of Bristol; then there's a Congreve Rocket, a 38-Pounder, to be let off—they use 'em in the wars, and kill all near.

All this is to be seen for only } 1S

Therefore, worry your Mothers, I say; and if they don't let you go, never be good again.

———

DOORS OPEN AT HALF-PAST SIX.

NEXT THURSDAY,

11th SEPTEMBER.

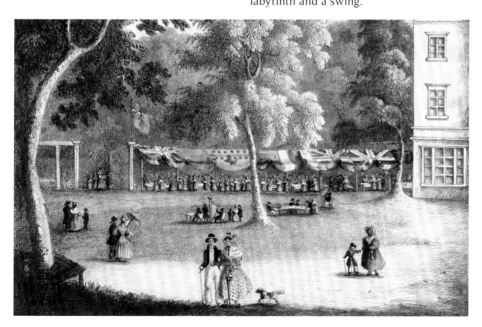

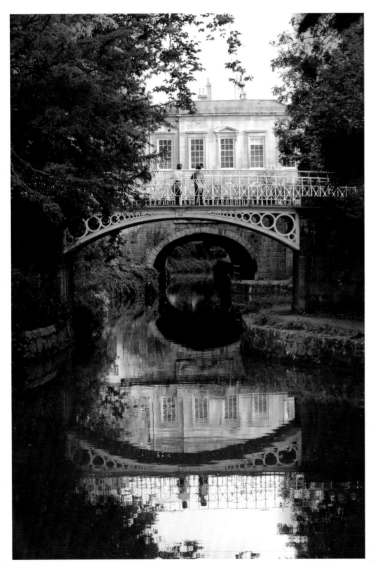

As the Kennet and Avon Canal (1794-1810) reaches Sydney Gardens it passes through two tunnels (left), the second of which courses under Cleveland House – the former office of the Kennet and Avon Canal Company. There is a gap in the roof of this tunnel, and legend has it that it leads to the cellars of Cleveland House, through which letters could be exchanged.

In 1909, Bath staged one of its most spectacular events – the Bath Historical Pageant. The extravaganza ran from 19-24 July and involved thousands of people, united the city and brought in many hundreds of visitors. This success was recognised a few years later when A. J. Taylor's

Minerva's Temple (above) – built to promote Bath at the Empire Exhibition, Crystal Palace in 1911 – was re-erected in Sydney Gardens in 1913, commemorating Bath's spectacular showpiece of civic pride.

(facing) John Claude Nattes, *Sydney Gardens and the Rear of Sydney House*, 1805, aquatint
This wonderfully vivid depiction of Sydney House clearly shows the large balcony where the orchestra played to the crowds below, and the supper boxes arching out like wings from the side of the house. Notice too the painting of Apollo playing his lyre attended by a putto (or cupid) on the wall of the semi-circular projection.

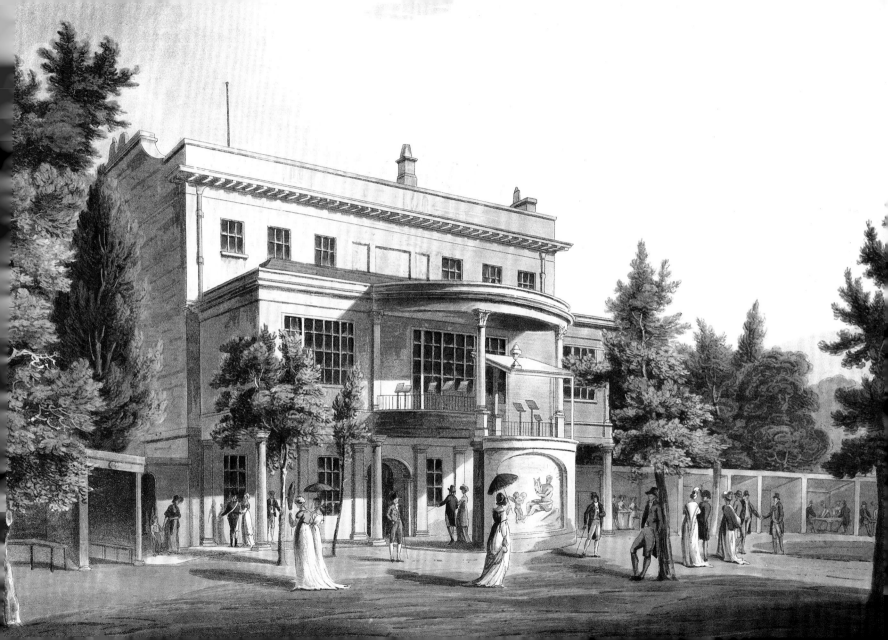

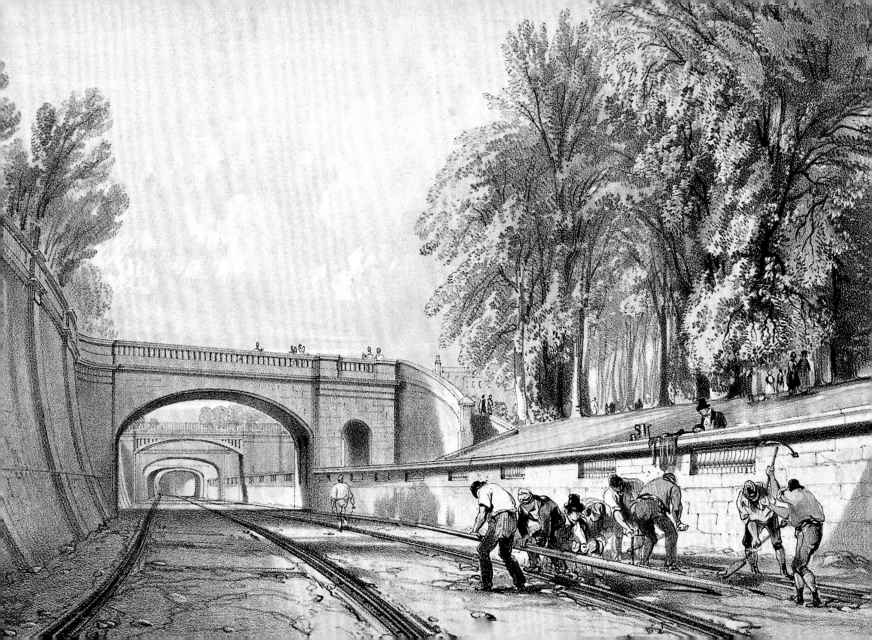

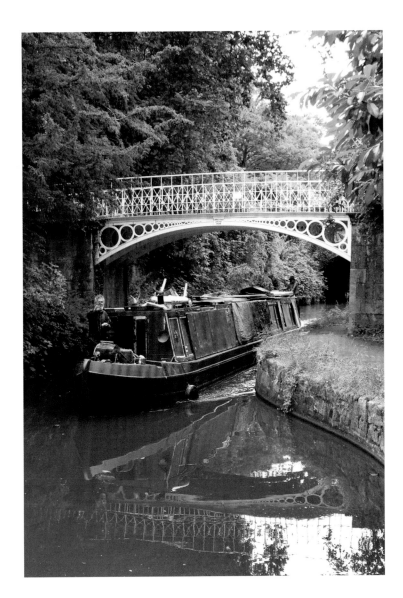

The canal, and then later also the railway, cut its way through Sydney Gardens, but the intrusion was tempered with sympathetic landscaping and decorative features, including iron bridges, tunnels and deep cuttings. John Rennie's (1761-1821) Kennet and Avon Canal bridged the 57-mile gap between the Kennet Navigation at Reading and the Avon Navigation at Bath, creating a major trade link between the ports of Bristol and London.

(facing) J. C. Bourne (1814-96),
***Sydney Gardens, Navvies,* c.1840,**
lithograph
The opening of Isambard Kingdom Brunel's (1806-59) broad gauge Great Western Railway route between London and Bristol in 1841 seriously undermined the canal. Ironic, as it was the canal that had enabled the railway to be built by bringing materials to site. In 1852, the canal was sold to the GWR and became rapidly run down and neglected. Between 1962 and 1990, a legion of volunteers set about restoring the canal and it is now completely reborn as a major place for tourism and leisure.

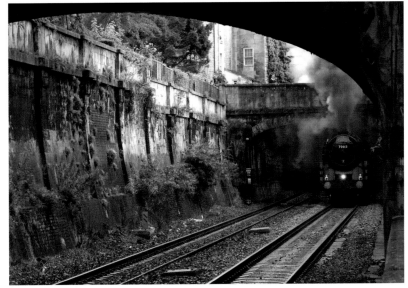

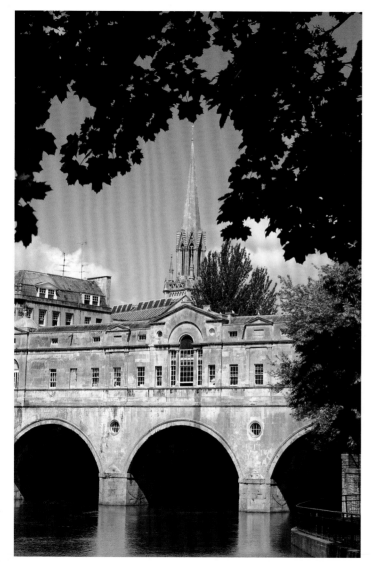

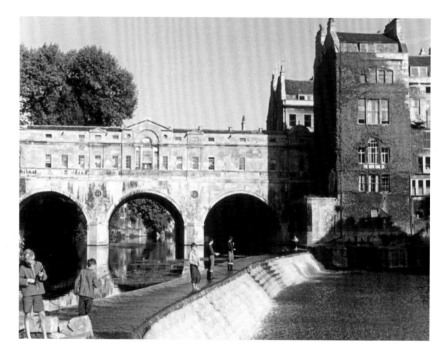

(facing) Mowbray A. Green, *Pulteney Bridge from Pulteney Weir,* c.1903, photograph
(above) *Boys fishing on the old weir,* c.1960, photograph

Pulteney Bridge (1769-74) is one of Bath's iconic landmarks. Designed by Robert (1728-92) and James Adam (1732-94), it enabled Sir William Johnstone Pulteney (1729-1805) to develop the Bathwick side of the River Avon, cut journey times to market and give more convenient access to pasture. The design is comparable with Palladio's unexecuted design for the Rialto Bridge in Venice, and is unique in Britain for having been designed with integrated shops. It has undergone a number of alterations over the decades – not all to its benefit.

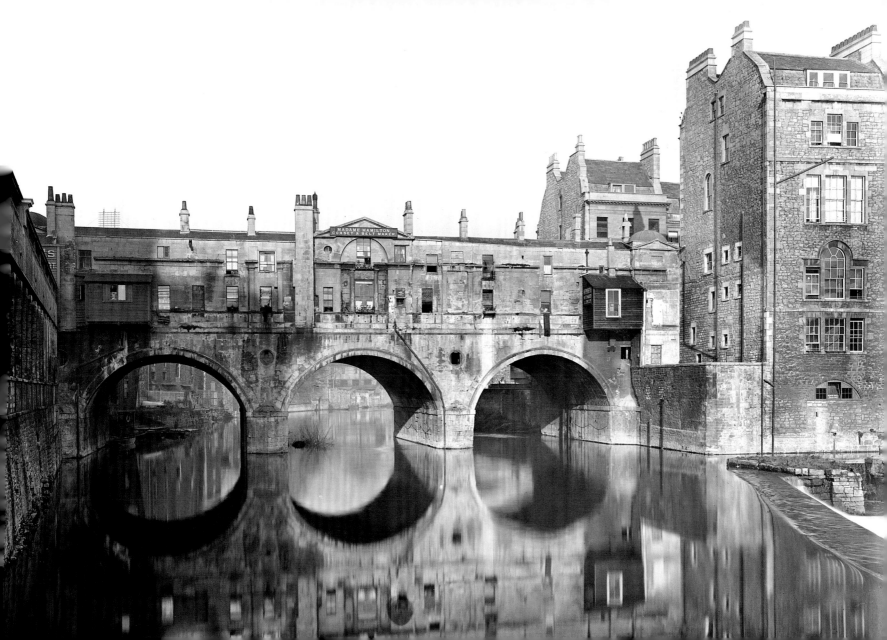

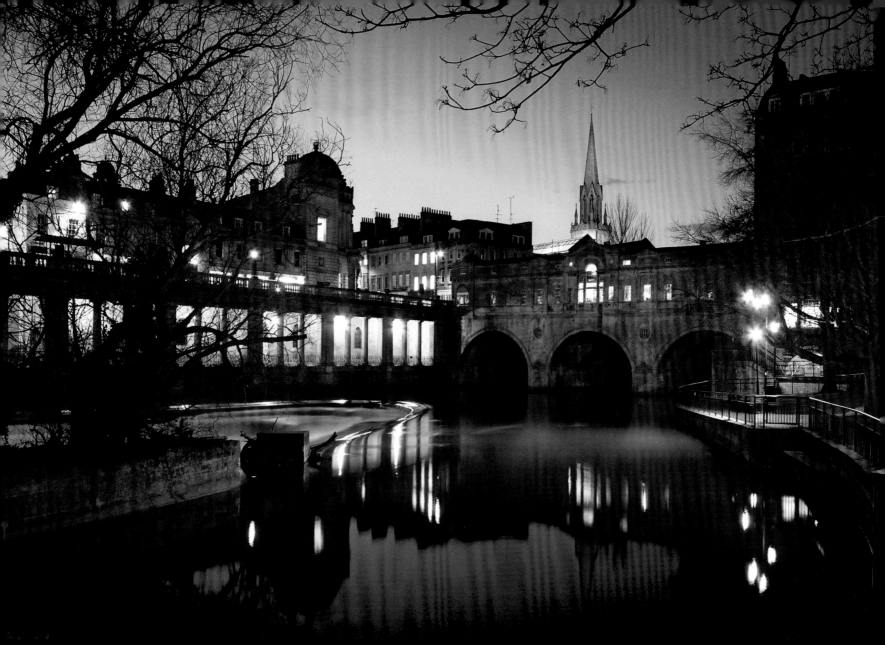

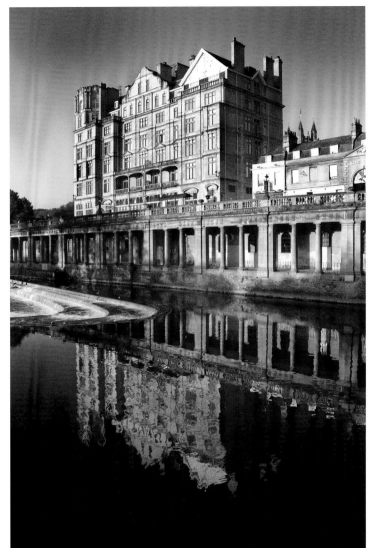

The poet, Sir John Betjeman (1906-84) believed Major Charles Edward Davis was a 'monster' for giving Bath the Empire Hotel (right, 1901). The height, architectural treatment and proximity to the Abbey, River Avon and Pulteney Bridge (facing) have consistently been levelled against it. Critics will have you believe that this was the final act of pompous revenge by Davis on a council who had thwarted his plans and made his professional life a misery. It is now luxury retirement flats with restaurants below. Love it or hate it, the eccentric Empire is Bath's only true example of a High Victorian building.

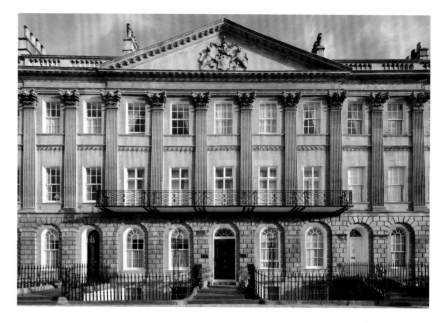

(facing) *Great Pulteney Street and Laura Place,* **c.1890, photograph**
Bathwick's prospects were greatly improved by the building of Pulteney Bridge. However, the construction of the bridge proved to be ten times more expensive than predicted, and a plan, inspired by Bath's Upper Town, to develop Bathwick profitably was formulated. The Adam Brothers prepared a scheme, but it was Thomas Baldwin who was entrusted to lay out Bathwick New Town. Building commenced in 1788 and proceeded rapidly.

The land was levelled, and the grand buildings were constructed over a vast vault system that raised them above the meadows. Just how impressive this engineering work was can easily be determined when you look up at the raised level of Johnstone Street from the Recreation Ground. Baldwin designed a system of crescents, squares and streets radiating off from the central spine of Great Pulteney Street (1788).

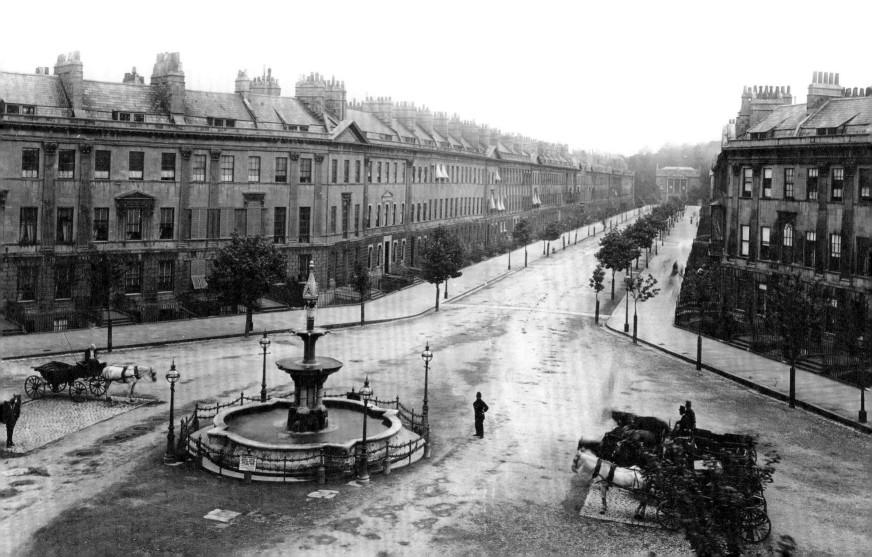

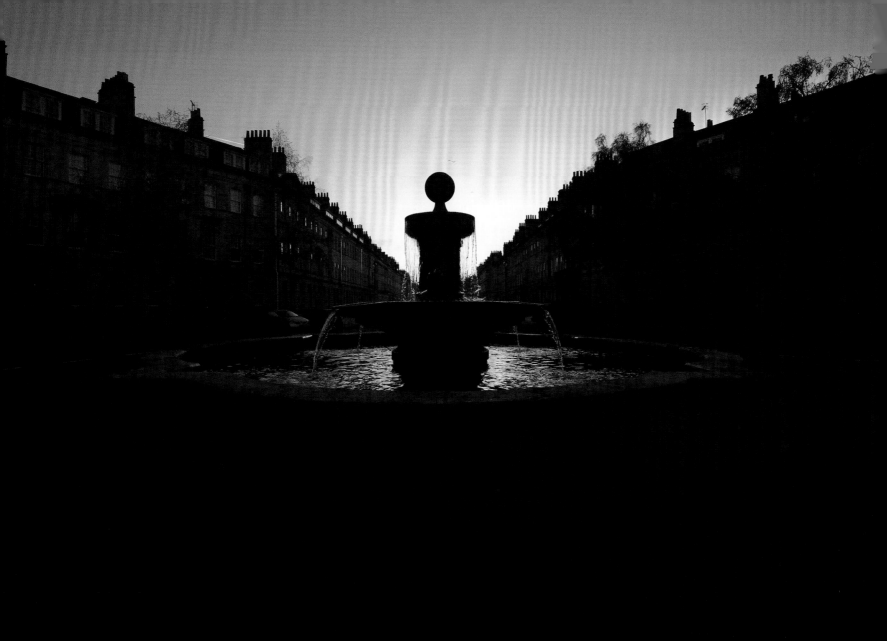

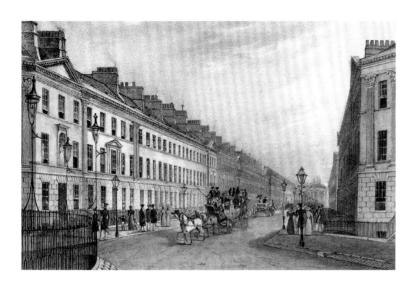

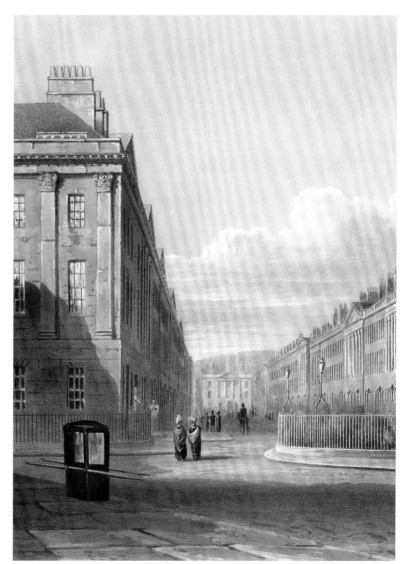

(right) David Cox, *Pulteney Street*, 1820, aquatint

Baldwin's work began with Laura Place (facing), where four streets of irregular widths meet. The grandest of the four is Great Pulteney Street, described as Bath's most impressive street. It divides to form a lozenge shape around Sydney Gardens and was intended to join up again as Upper Pulteney Street and continue in the same magnificent way. As the development of Bathwick was mainly speculative, those involved had borrowed on credit. When the banks collapsed in 1793, creditors called in their loans, resulting in a wave of bankruptcies.

(above) Giles (after R. Woodroffe), *Great Pulteney Street*, c.1830, lithograph

Over 200 years later Bathwick still carries the scars of this financial collapse. Halfway up Great Pulteney Street, on the left, is Sunderland Street, only one house long, but it was intended to lead to an impressive residential area to be called Frances Square after Pulteney's wife. On the right are three more incomplete roads, namely Johnstone, William and Edward (further family names). They were designed to lead to Great Annandale Street, which would have run parallel to Great Pulteney Street.

After the bank crash of 1793, construction in Bath became increasingly less speculative and more commission based. John Pinch the Elder (1770-1827) took over work on the Pulteney estate after Thomas Baldwin's bankruptcy. Pinch survived the bust by providing more modest and affordable houses for the emerging middle class. Raby Place (facing, 1818-25) elegantly steps up Bathwick Hill – Pinch's use of a ramped cornice and stringcourse aids the flow.

Bath enjoys a number of noteworthy annual events and festivals, including the Bath Half Marathon (below), which attracts 15,000 runners and many more spectators. It was established in 1981, one year after the London Marathon, and raises over £1.2 million annually for charity.

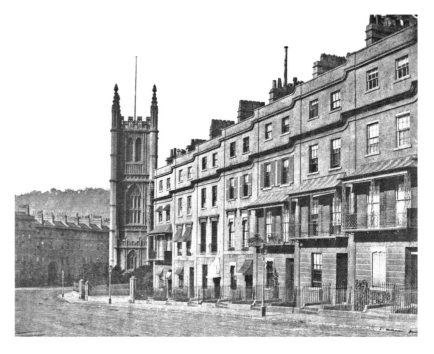

(above) Reverend Francis Lockey (1769-1869), *St. Mary's Church Bathwick and Raby Place,* **c.1853, calotype photograph**
Bath's most popular famous former resident is Jane Austen (1775-1817). Austen's association with Bath commenced with visits to her maternal aunt, Mrs Leigh Perrot, who lived on the Paragon. Austen lived in Bath for five years from 1801 to 1806 in properties on Gay Street, Green Park Buildings and Sydney Place. Her novels *Northanger Abbey* and *Persuasion* are set in Bath, whilst all her other novels make mention of the city.

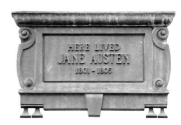

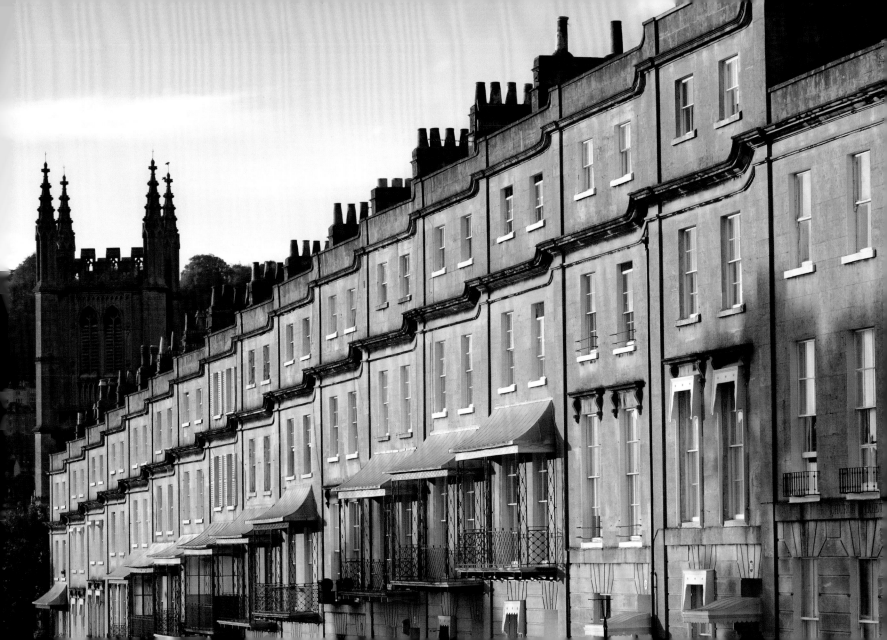

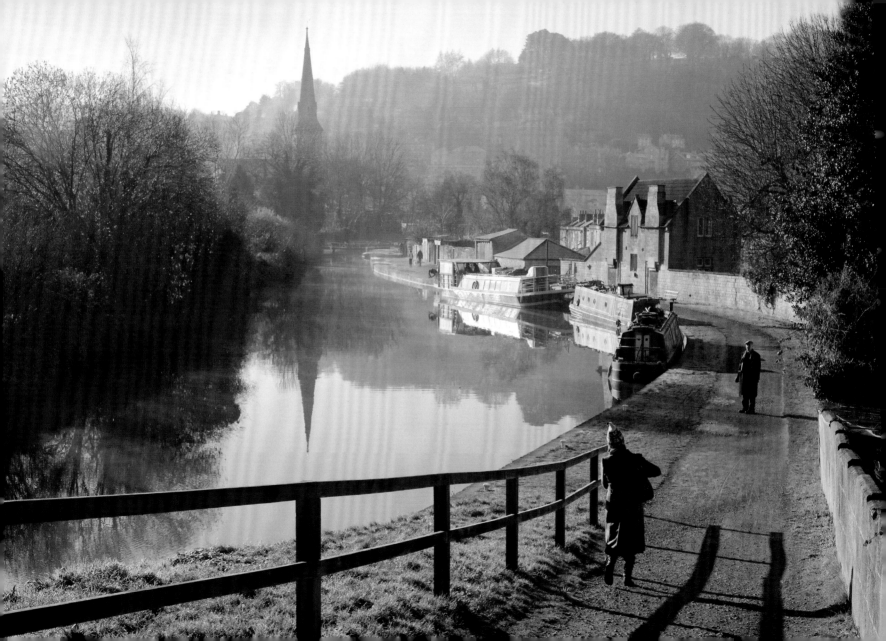

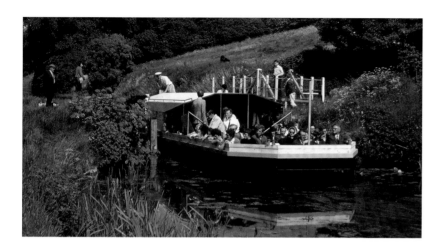

(above) *Passengers on a Pleasure Boat on the Kennet and Avon Canal at Bathampton*, c.1964, **photograph**

John Wood identified the need to improve the River Avon as 'a necessary prelude to the architectural developments' he visualised for Bath. Attempts had been made since at least the 1500s to navigate the Avon, whilst serious schemes to link the Thames and Avon are recorded from the 1600s.

In May 1724 John Hobbs, a Bristol timber merchant, set up a stock company to make the Avon navigable. Ralph Allen was one of 32 shareholders. Work to deepen and widen the Avon between Bath and Bristol began in 1725. Wood was offered the contract for a 600 yard (550m) stretch at Twerton. It was during this contract that Wood claimed he introduced the spade to Bath. The first narrowboat travelled from Bristol to Bath in December 1727 carrying timber, pig-iron and meal.

Canal fever was sweeping the country during the second half of the 18th century; Britain's prowess as an industrial nation demanded good communications for the transportation of raw materials and goods.

Originally the canal was to join the Avon at Bathampton, but the fear of seasonal flooding making the route impassable led to the decision to carry the canal on to Bath where it joins the Avon at Widcombe.

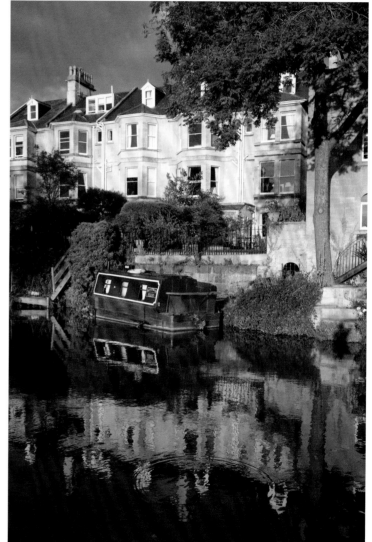

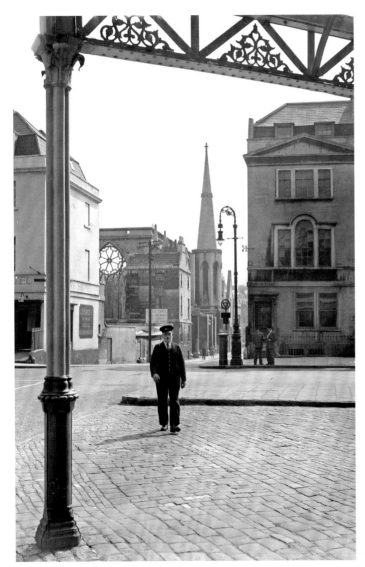

(left) *View from under the canopy of Green Park Station, in the background the rose window of Holy Trinity Church, James Street West, burnt out during the Bath Blitz of April 1942* **c.1946, photograph**

Green Park station cost £15,625 to build in 1869, and served a ten-mile branch line from the main Bristol to Birmingham line at Mangotsfield. From 1874 it was also used by the Somerset and Dorset Railway Company. Travel between the south coast and the north of England flourished and, in 1910, the Midland Railway introduced a through service between Manchester and Bournemouth called the 'Pines Express'. It ran until September 1962.

(facing) *Enthusiasts gather at Green Park Station to see Class 7F 2-8-0 No. 53807,* **7 June 1964, photograph**

The station was a masterpiece of mid-Victorian railway architecture. A glazed and ornamental cast-iron porte-cochère enhanced the entrance, which led through the hall to an iron framed single span roof (below), which covered the platforms and track. The fine ironwork led to the station being called the mini St. Pancras. As a consequence of Dr Beeching's reforms, the station closed in 1966. Throughout the 1970s it was known as Bath's 'white elephant', and finding an agreeable use for the site was fraught with conflict and politics. Happily, the station buildings now house a thriving, bustling complex of independent shops and stalls, a farmer's market, restaurants and meeting rooms.

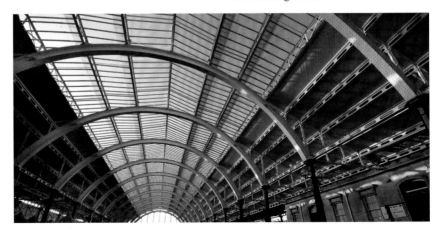

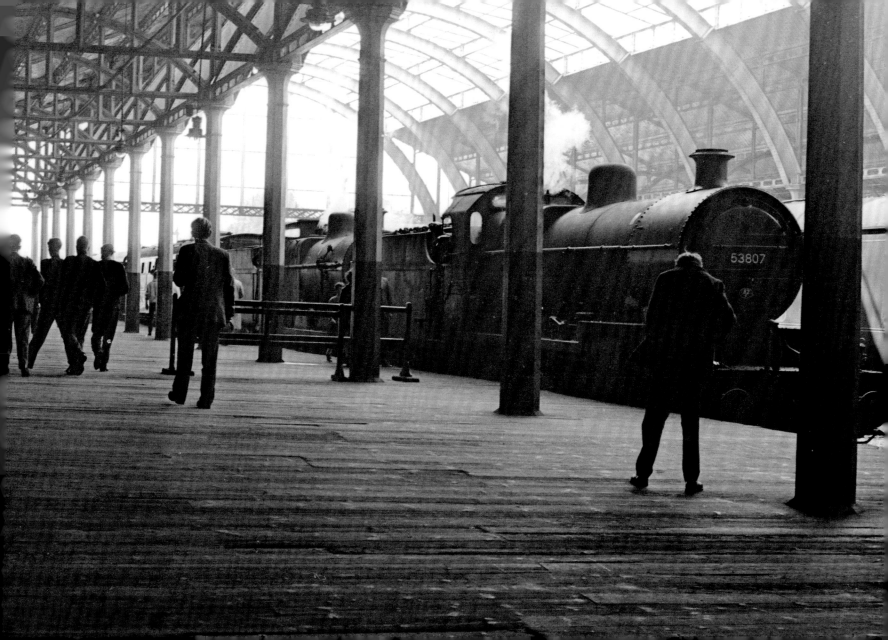

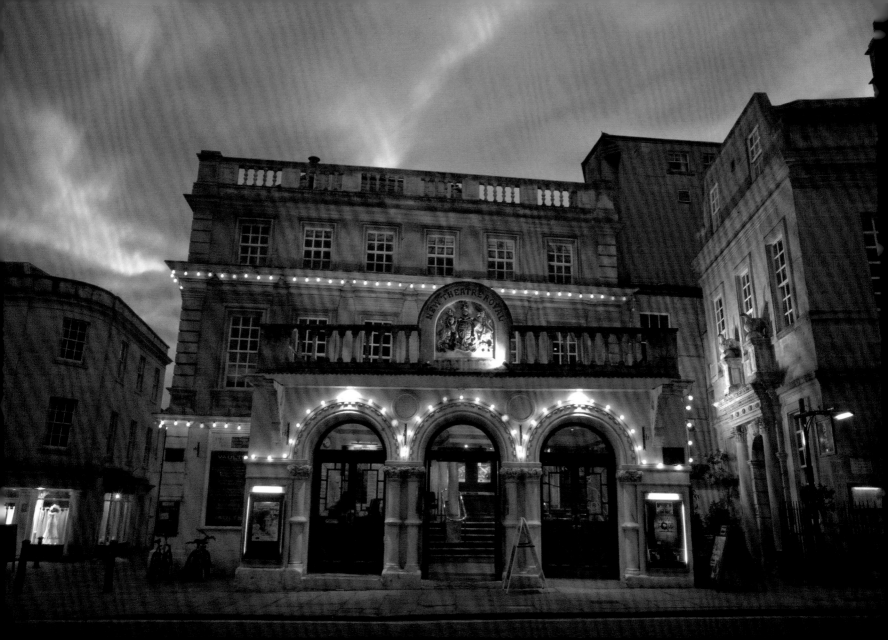

(below) *Inside the Theatre Royal, after the Fire in 1862,* **one side of stereoscopic photograph**

In April 1862 *The Times* newspaper reported, 'The beautiful theatre, which was one of the ornaments of the city of Bath, and which since its erection in 1805 has contributed so much to the reputation of the city as a place of amusement by the excellence of the dramatic representations constantly presented, was on Good Friday totally destroyed by fire. It was built at a cost of about £25,000 and was regarded as one of the, if not the most compact and elegant of provincial theatres.'

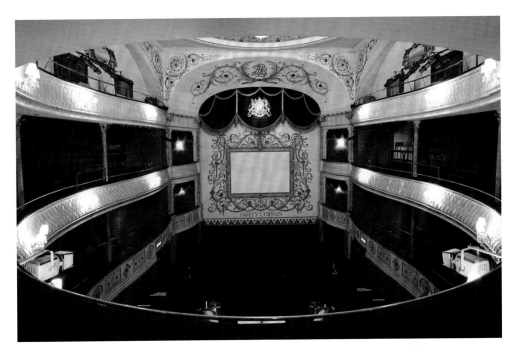

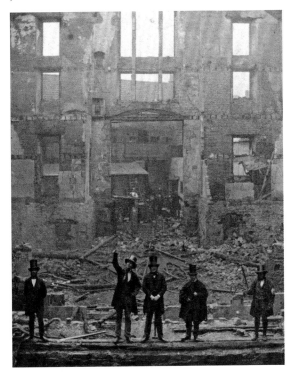

The interior (above) was rebuilt by C. J. Phipps (1835-97), who moved the main entrance from Beauford Square, with its façade designed by George Dance the Younger (1741-1825), to the Saw Close side. The auditorium comprises the stalls and three tiers of balconies in a horseshoe shape. Boasting stone eagles above its doorway, the house to the right of the Theatre Royal's main entrance (facing) was the home of Richard 'Beau' Nash. For many years it retained the name of Popjoy's, pertaining to Juliana Popjoy, one of Nash's more notorious mistresses.

New Theatre-Royal, Beaufort-Square, Bath,

WILL OPEN this present SATURDAY, OCTOBER 12, 1805,

With Shakspeare's Historical TRAGEDY of

King Richard III

With entire new Scenery, Dresses, Machinery, and other Decorations.

Richard, Duke of Glofter By A GENTLEMAN,
(His First Appearance on the Stage.)
King Henry the Sixth Mr CHARLTON.
Prince of Wales · · · · · · Mifs MARTIN.
Duke of York · · · · · · · · Mifs L. QUICK.
Duke of Buckingham Mr. CAULFIELD,
(From the Theatre-Royal, Drury-Lane, his First Appearance on the Bath Stage.)
Duke of Norfolk · · · · Mr. EGAN.
Earl of Oxford · · · · · · Mr. ABBOTT.
Henry, Earl of Richmond Mr. EGERTON.
Lord Stanley · · · · · · · · Mr. RICHARDSON,
(His First Appearance here these three years.)
Lord Mayor of London Mr. EVANS.
Sir W. Brandon · · · · · · Mr. CUNNINGHAM.
Sir Richard Ratcliffe · · Mr. CUSHING,
(His First Appearance here.)

Sir Wm. Catefby · · Mr. GOMERY.	Sir James Blunt Mr. EDWARDS.
Sir R. Brackenbury Mr. GATTIE.	Dighton · · · · · · Mr. LODGE.
Sir James Tyrrel · · Mr. KELLY.	Foreſt · · · · · · · · Mr. SIMS.

Queen Elizabeth · · Mifs FISHER.
Duchefs of York · · · · Mrs. CHARLTON.
Lady Anne · · · · · · · · Mifs JAMESON.

The SCENES, by Meſſrs. Greaves, Marchbank, French, and Capon.
The DRESSES by Mr. Quick and Assistants.—The Female DRESSES by Mrs. Jefferies.

To which will be added the Musical ENTERTAINMENT of The

POOR SOLDIER.

Patrick · · · · · · · · · · · · · Mifs WHEATLY,
(From the Theatre-Royal, Covent-Garden, her First Appearance on this Stage.)
Father Luke · · · · Mr. RICHARDSON. | Captain Fitzroy · · Mr. CUSHING.
Dermot · · · · · · · · Mr. WEBBER. | Bagatelle · · · · · · · · Mr. GATTIE.
Darby · · · · · · · · · · · Mr. MALLINSON.

Kathleen · · · · · · · · · · · · Mrs. SIMS.
Norah · · · · · · · · · · · · · · Mrs. WINDSOR.

Boxes 5s. Pit 3s. Gallery 1s. 6d. Latter Account, Boxes 3s. Pit 2s. Gallery 1s.
Tickets and Places for the Boxes to be taken of Mr. BARTLEY, at his House in Orange-court, Grove.
N.B. The Carriage Entrance to the Boxes is in the Sawclose ; and Ladies and Gentlemen are particularly requested to order their Servants to set down with their Horses' heads towards Weſtgate-street, and to take up with their heads towards Queen's-square, to prevent confusion. The entrance for Chairs is in Beaufort-square, and the entrance to the Pit and Gallery is in St. John's-court.

Ann Keene, Printer, 7, Kingmead-street, Bath.

116

(left) *King Richard III* Playbill for Opening Night at the New Theatre Royal, 12 October 1805
The new theatre, designed by George Dance the Younger and built by John Palmer, opened with a Shakespearean tragedy, followed by the much lighter musical *The Poor Soldier*, thereby appealing to all tastes. The note at the end makes interesting reading: 'The Carriage Entrance to the Boxes is in the Sawclose; and Ladies and Gentlemen are particularly requested to order their Servants to set down with their Horses' heads towards Westgate-street, and to take up with their heads towards Queen's-square, to prevent confusion. The entrance for Chairs is in Beaufort-square... the Pit and Gallery is in St. John's-court.'

(facing) *Sawclose, Blue Coat School and Palace Theatre*, 1936, photograph
As the name suggests, Sawclose was the timber yard (or green), located in the north-west corner of the old city where timber for construction was sawn into shape.

The Blue Coat School was founded in 1711, and among its alumni are architects John Wood and George Phillips Manners. It was a charity school, providing for children from the deserving poor. The current building was designed (1859-60) by Manners and John Elkington Gill (active 1845-1903), and provided places for 60 boys and 60 girls. The school got its name from the children's uniform.

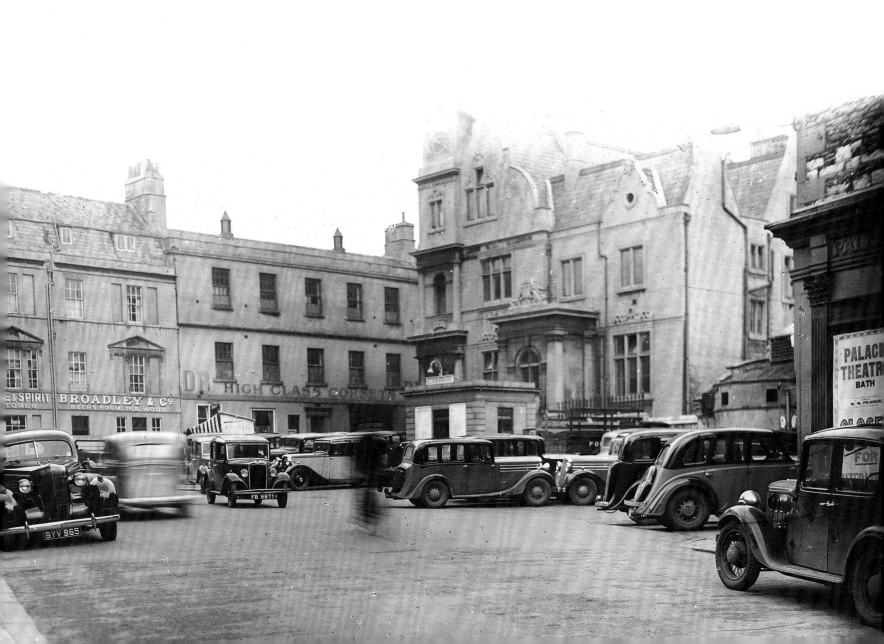

The annual Christmas Market (above and right) is a hugely popular event with many retailers in traditional wooden chalets cheek-by-jowl around the Abbey. A significant proportion of the stall holders are local crafts people and traders, allowing for a wealth of beautifully made and unique gifts. The market is internationally renowned and regularly voted as one of the world's best Christmas markets, with carol singers, children's entertainers and musicians adding to the festive ambience.

The smell of mulled wine and chestnuts, mixed with the lights and cold winter air, ensures that this event is guaranteed to get anyone into the Christmas spirit.

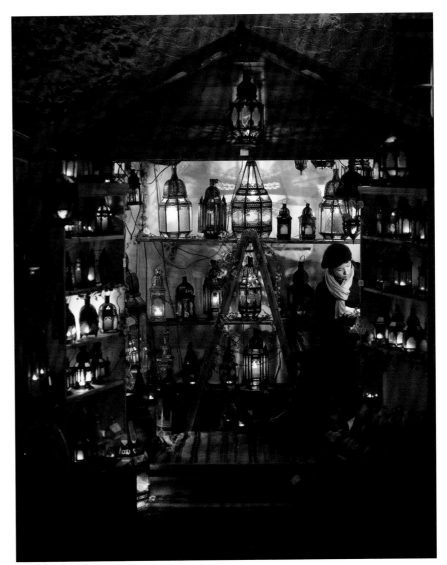

(below) *Floods on Southgate Street,*
July 1968, photograph

Until Pulteney Weir (p.102-3) was rebuilt in 1968-72 as part of the flood prevention scheme, Bath flooded regularly. As Bath grew, and more and more industry was based along the River Avon, the consequences were all the more devastating. During the 19th century Bath experienced regular flooding, the most serious being in 1809, 1823, 1866, 1882 (known as the Great Flood), 1888, 1889 and 1894. Unsurprisingly, the lower areas that flooded regularly – such as the Dolemeads and Avon Street – quickly became run down slums.

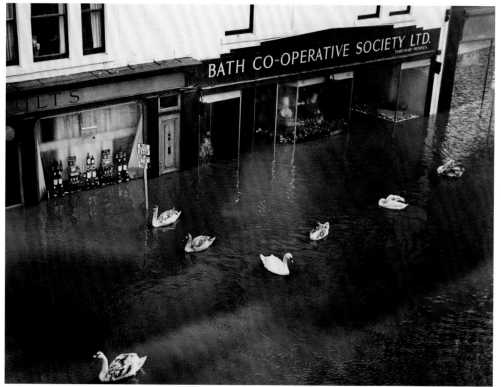

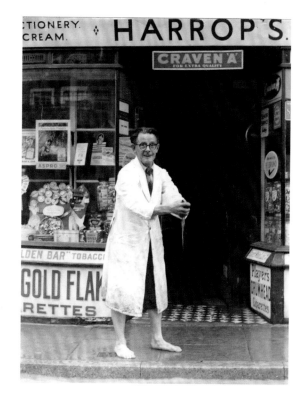

(above) *Mr Arthur Harrop mops out his shop in Weston Village,* **1968, photograph**
(facing) W. G. Lewis, *James Street and Holy Trinity Church Flooded,* **25 October 1882, photograph**

In July 1968 a huge storm over Somerset, after a severe drought, resulted in floodwater ten feet (3m) deep in some places – seven people died and many more were left homeless. In Bath, cars were abandoned as the main thoroughfares became rivers. Fortunately, this was Bath's last 'great flood' as the flood defences have proved effective since then.

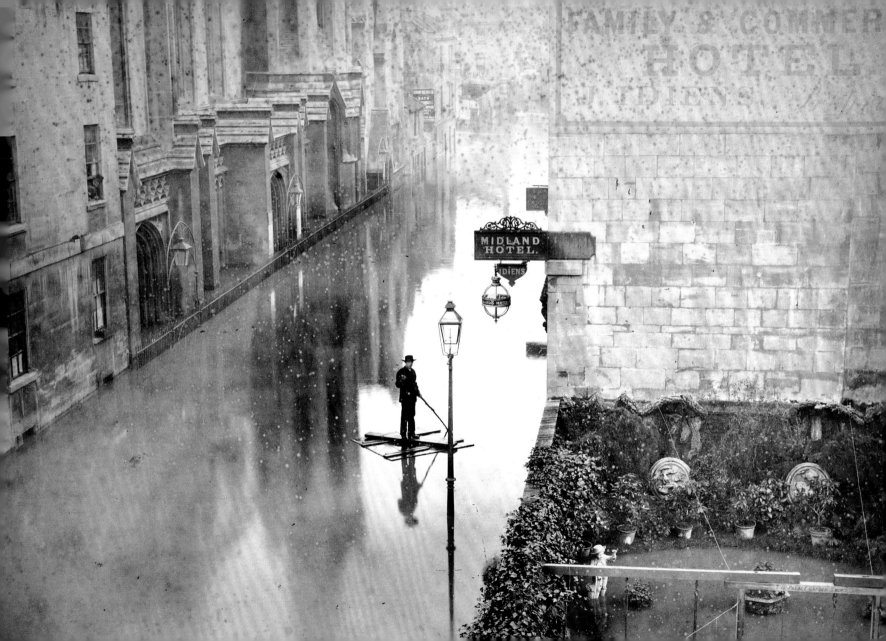

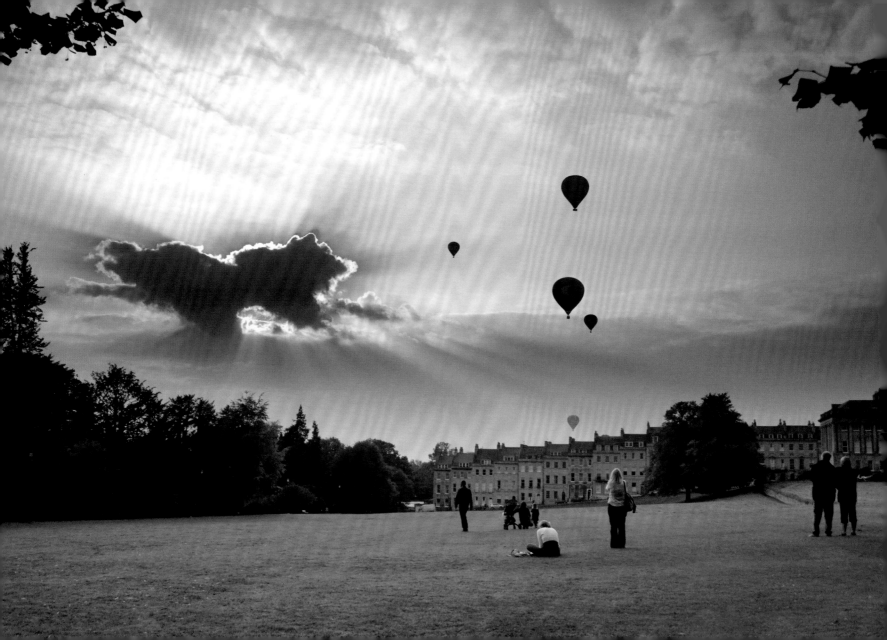

(below) *Colossal Head sculpted by John Osborne from a block of Bath stone. Erected in Royal Victoria Park, October 1839*, printed by J. Hollway

(right) *Plan of the Royal Victoria Park*, 1856, printed by Hollway & Son

Royal Victoria Park is one of Britain's earliest great public parks outside of London. It was opened in 1830 by Princess (later Queen) Victoria and was the first park to be named in her honour. In the 19th century parks were identified as a means of moral regeneration, as it was hoped that their charms were more attractive than the pub and could therefore keep families together. Royal Victoria Park remains a popular haven for Bathonians and visitors of all generations.

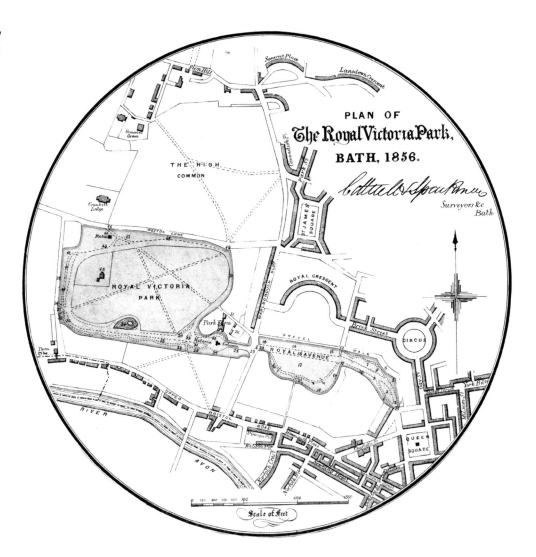

PLAN OF
The Royal Victoria Park,
BATH, 1856.

Cattle & Spackman
Surveyors &c
Bath

Scale of Feet

Despite its historic image, Bath is constantly regenerating and it can be surprising how much modern architecture and new building there is. The recent £360 million SouthGate shopping area (2006-10), designed by Chapman Taylor for Morley Fund Management and Multi Development, has replaced Owen Luder's unpopular 1973 version. The nine acres of new shops and residential apartments blend successfully with Bath's traditional, family run businesses, such as George Bayntun (right), one of the world's most famous bookshops

and home to the Bayntun-Rivière bindery, which dates back to 1829.

A few steps away from SouthGate is Isambard Kingdom Brunel's distinctive railway station (below, 1840-1) with its Flemish gables and Jacobean mullion windows. More than four million passengers pass through Bath Spa Station every year. As part of the wider redevelopment of this area, a new transport interchange, designed by Wilkinson Eyre, was introduced to enable more streamlined travel

between train and bus. Together this main gateway to Bath for tourists, shoppers and commuters has been greatly enhanced.

The breathtaking history of Bath extends over six millennia; a constant theme is the lure of its hot springs. An international icon of elegant architecture, boutique shopping, fashionable restaurants and exclusive spa facilities, Bath is a destination city. Its popularity has certainly wavered over the centuries, and not all attempts to revive the city have been successful, but it is perhaps this floundering that makes Bath more amiable, more 'human'. A popular, modern, thriving city, Bath does its best to adapt to the often conflicting demands of being a heritage site of unique importance and a modern provider of homes, jobs and education.

Undoubtedly, to know Bath is to love Bath – a truly extraordinary city.

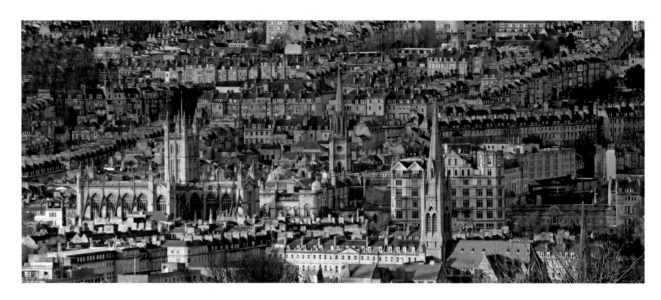

Contemporary photography by:

Dan Brown
www.bathintime.co.uk
16R, 19, 37, 47L, 64R, 69, 71R, 72R, 76, 87L&R, 125, 126

Andy Clist
www.photosofbath.co.uk
24R, 28R, 59R, 79R, 91L, 103L, 119L, 124R

Mark Gibson
www.jibbosan.com
9, 10, 11, 15, 16L, 18, 20, 21, 22, 24L, 27L&R, 28L, 31L&R,
40, 41, 44L, 48, 55L, 60L, 61, 62, 72L, 75, 79L, 80, 82, 83,
84L&R, 88L, 90, 91M, 96L, 102, 104R, 106, 108R, 109, 110,
115, 118, 119R

Jess Loughborough
www.sunfacethirteen.co.uk
4, 23, 32, 35L, 39L, 47R, 64L, 67L&R, 88R, 92L&R, 100, 108L

Richard Schofield
www.tripodape.co.uk
33, 34, 35R, 43L&R, 44R, 49, 56, 59L, 60R, 68, 71L, 74, 77,
99L&R, 103R, 112, 124L

Christina West
www.christinawest.co.uk
30, 36L, 39R, 52&53, 55R, 63, 91R, 94, 96R, 104L, 111, 114,
116, 122, back cover